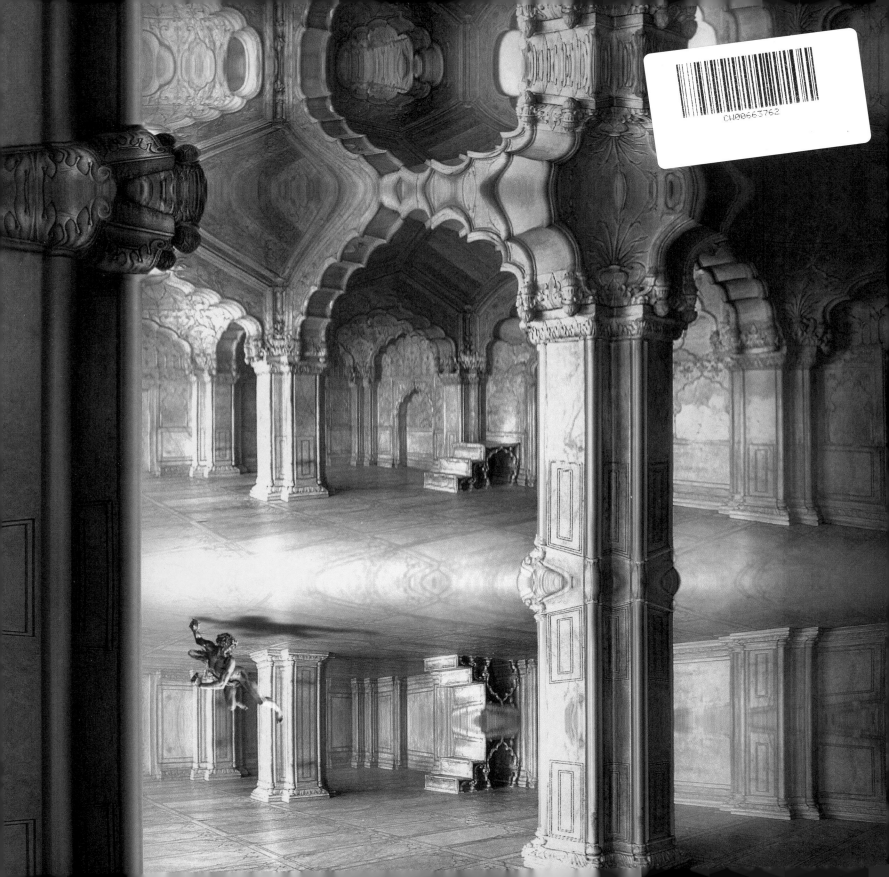

ISBN 81-7508-343-3

ARTWORKS & DESIGN
© Jörg Huber, 2002

PROCESSING
Reproscan

PRINTING / FINISHING
Silverpoint / Tellurian

PUBLISHED BY
India Book House Pvt Ltd
412 Tulsiani Chambers
Nariman Point, Mumbai 400 021, India
Tel 91 22 284 0165 Fax 91 22 283 5099
E-mail info@ibhpublishing.com

MIRRORS OF LOVE

compiled by
DANA GILLESPIE

artwork by
JÖRG HUBER

IBH
INDIA BOOK HOUSE PVT LTD

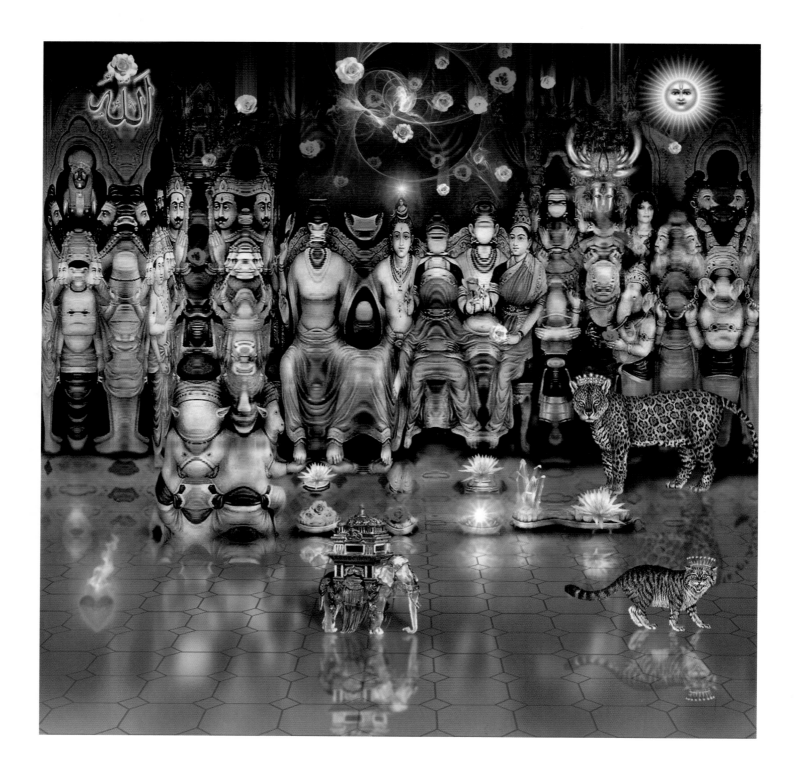

Many years ago, in a dream that was so vivid it was more like a vision, I was given a mirror from the Beloved. The experience was so real that I remained in a state of bliss for days. For a long time I pondered on the significance of the mirror and at first, took it to mean that I must look at my own faults, rather than the faults of others, knowing full well that the finger of accusation that points at others, has three fingers pointing back at oneself. However, through the years, I have come to realise that the mirror has a much deeper meaning, for the mirror is our own Self, and if we are to reflect God and His greatness, then the mirror, which is ourself, must be polished and made shiny, so as to reflect only Him. For what other reason are we here but to become beacons of light, to shine from within, to love all and serve all, and to help ever and hurt never. These writings are some of the gems of enlightened beings and they are, as the title suggests, mirrors of love. I dedicate this book to the Beloved and I fall gratefully at His feet.

— DANA GILLESPIE

This collection of pictures has been created over 35 years. When I started painting in the late '60s, I was using watercolours, gouache, acrylics and oils but the first moment that computers came on the scene, I was fascinated by their limitless possibilities in creating images. It's many years since I swapped the canvas for the computer screen but sometimes, when I'm travelling to faraway places, I still use the brush and watercolour with great contentment. For me, the quality and essence of art is based on love in any form.

— JÖRG HUBER

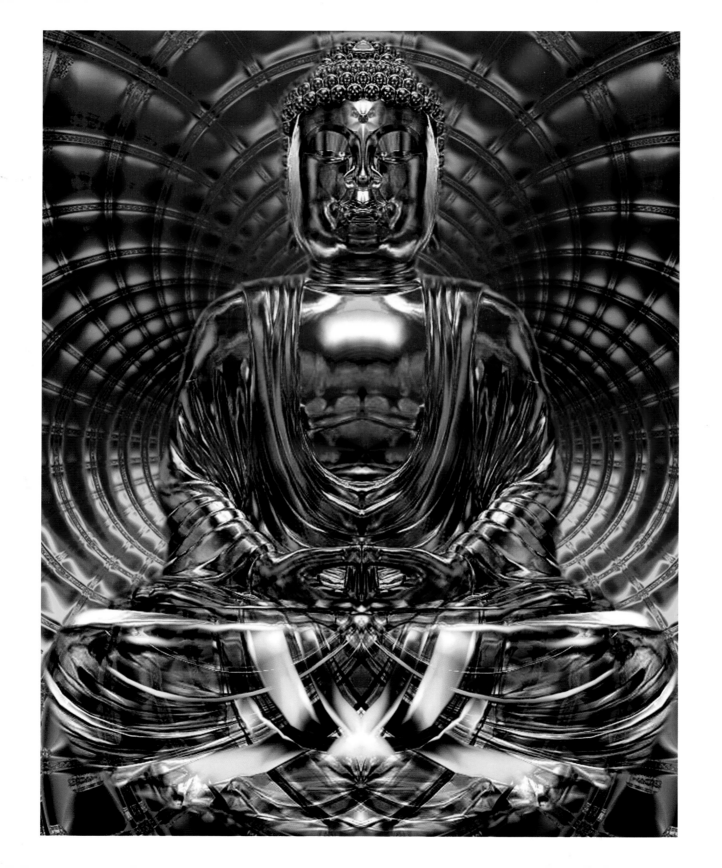

At the moment you entered this world, a ladder was placed in front of you to allow you to escape. First you were a mineral, then you became a plant, then you became an animal. How could you ignore it? Then you were made into a man, gifted with knowledge, reason and faith. Observe this body, drawn from dust; what perfection it has acquired! When you have transcended the condition of manhood, you will become an angel. Then you will have done with this earth and your dwelling will be in heaven. Go beyond the angelic condition, dive into this ocean, so that the drop of water that is You, can become a sea.

RUMI

At times I catch the echo of Your voice in my song. Then my madness grows with joy and I sing again and again ... not to hear my own voice but to catch the echo of Your voice in my song.

SWAMI PARAMANANDA

A path and a gateway have no meaning once the objective is in sight.

HUJWIRI

As soon as I attained to Oneness, I became a bird with a body of Unity and wings of everlastingness, and I continued flying in the air of quality. I thought that I had arrived at the very throne of God and I said to it "Oh throne, they tell us that God rests upon you" but the throne replied "We are told that he rests in a humble heart".

ABU BAYAZID AL-BISTAMI

A secret is hidden in the rhythms of music. Should I reveal it, it would upset the world.

RUMI

As long as I was a lion, chasing the leopard was my way. I overcame all that I thought I may. But since I gave place to Thy love in my heart a lame fox can drive me out of the forest, strange to say.

ABU SAID ABI'L-KHAIR

A single day on the Path of Love is better than the world and all it contains.

TRADITION

All things under Heaven have a beginning, which is to be regarded as the Mother of all things. If one knows the 'mother', one knows the 'child', and if, after having known the 'child' one goes back to the 'mother' and holds fast to her, one will never fall into a mistake until the very end of one's life.

LAO-TZU

A man cannot enter into the deepest centre of himself and pass through that centre into God, unless he is able to pass entirely out of himself and empty himself, and give himself to other people in the purity of a selfless love.

THOMAS MERTON

All is change in the world of senses, but changeless is the supreme Lord of Love.

SHVETASHVATARA UPANISHAD

As the body is clad in clothes, and the flesh in the skin, and the bones in the flesh, and the heart in the whole, so are we clothed, body and soul, in the goodness of God, and enfolded in it.

JULIAN OF NORWICH

Ask and it shall be given you, seek and you will find, knock and the door will be opened to you. For everyone that asks, receives, and he that seeks will find, and to him that knocks, the door will open.

ST MATTHEW 7:7

An eye for an eye only ends up making the whole world blind.

MAHATMA GANDHI

A man has no way of becoming benevolent unless he understands Destiny.

CONFUCIUS

After enlightenment, one sees all things and objects as but magic shadow plays, and all objective things become his helpful friends.

MILAREPA

All know that the drop merges into the ocean but few know that the ocean merges into the drop.

KABIR

Art, as the disclosure of the deeper reality of things, is a form of knowledge. The artist discerns, within the visible world, something more real than its outward appearance, some idea or form of the true, the good and the beautiful, which is more akin to the spirit itself than to the visible things. Poetic truth is a discovery, not a creation.

SARVEPALLI RADHAKRISHNAN

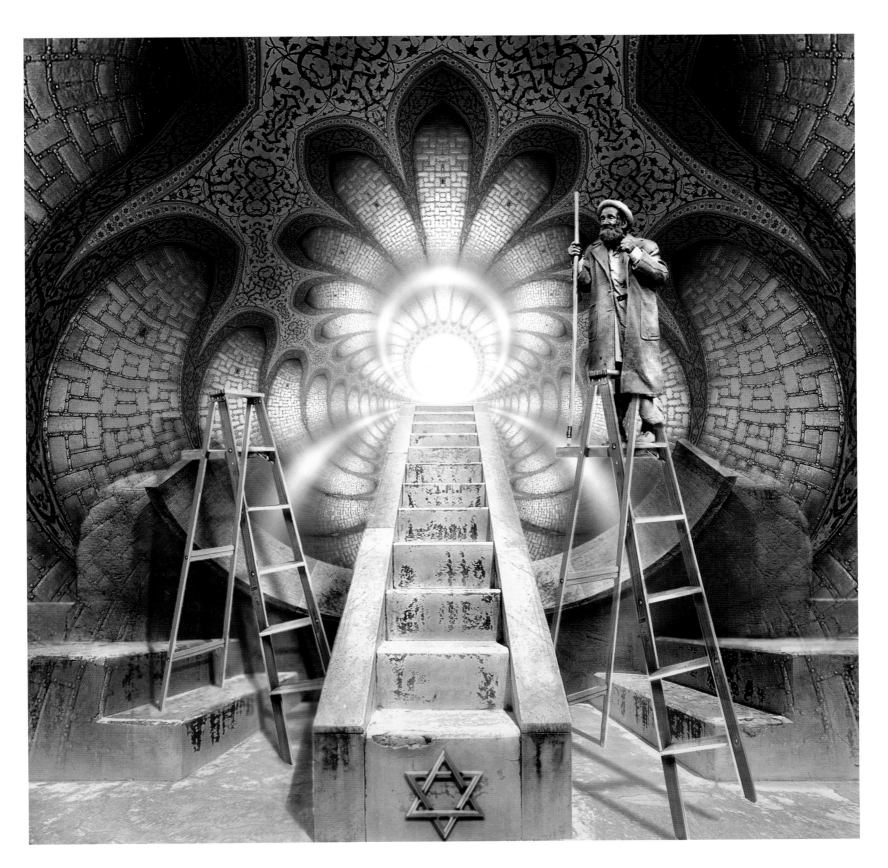

An ounce of practice is worth more than tons of preaching.

MAHATMA GANDHI

Asceticism is not that you should not own anything, but that nothing should own you.

ABU TALIB

As butter lies hidden within milk, the Self is hidden in the hearts of all.

AMRITABINDU UPANISHAD

All are made of the same elements, none high nor low when born.
The same glow shines in everyone, in the heart of every man.

KABIR

An arrow from the quiver of love has pierced my heart and driven me crazy.
I offer my body and mind to all holy men, and I hug closely those lotus feet.

MIRABAI

As hard as 'tis along a razor's edge to fare,
So hard is it to tread the Path, the wise declare.

KATHA UPANISHAD

All are architects of Fate,
Working in these walls of Time;
Some with massive deeds and great,
Some with ornaments of rhyme.

HENRY LONGFELLOW

As fragrance is in the flower, so is the Lord within you, but He reveals Himself to His beloved saints. That is all you need to know; go forth and meet them.

KABIR

All that belongs to this visible world is corruptible and mortal. All that belongs to the Divine world is incorruptible and eternal.

ABBAS EFFENDI

All religions are the same. They all lead to God. God is everybody. The same blood flows through us all; the arms, the legs, the heart, all are the same. See no difference, see all the same.

NEEM KAROLI BABA

As the rivers flowing East and West merge in the sea and become One with it, forgetting they were ever separate streams, so do all creatures lose their separateness when they merge at last into the pure Being.

CHANDOGYA UPANISHAD

 Anger is the enemy of non-violence and pride is a monster that swallows it up.

MAHATMA GANDHI

As the lotus dies without water, as the night is blind without the moon, so is my heart without You, my Beloved.

MIRABAI

As a dusty mirror shines bright when cleansed, so shines the one who realises the Self, attains life's goal, and passes beyond sorrow.

SHVETESHVATARA UPANISHAD

All things of the Universe are links of a single chain. Shake but a flower and a star will shiver and turn.

FIRAQ GORAKHPURI

All beauty and brightness derive from His grace. It's but His spark divine that sets the sun ablaze.

MIR TAQI MIR

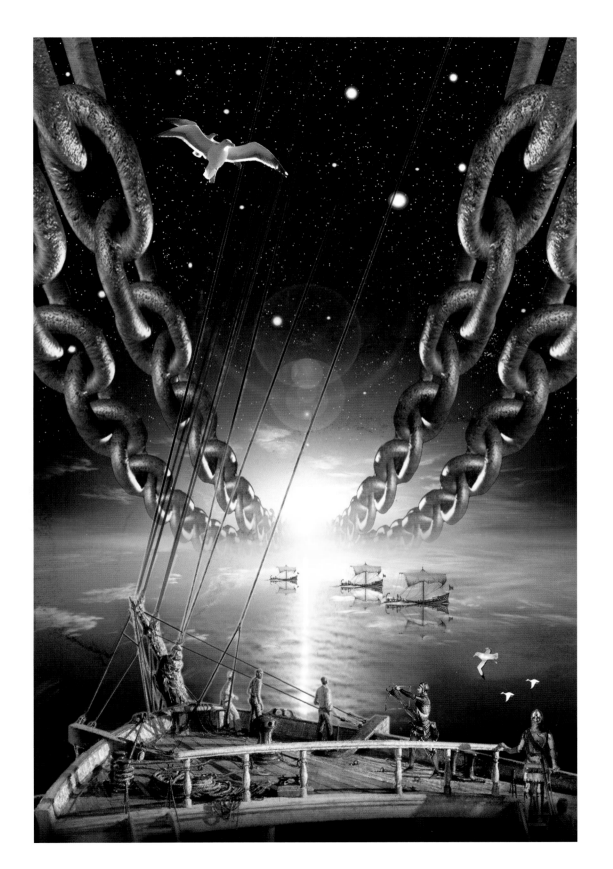

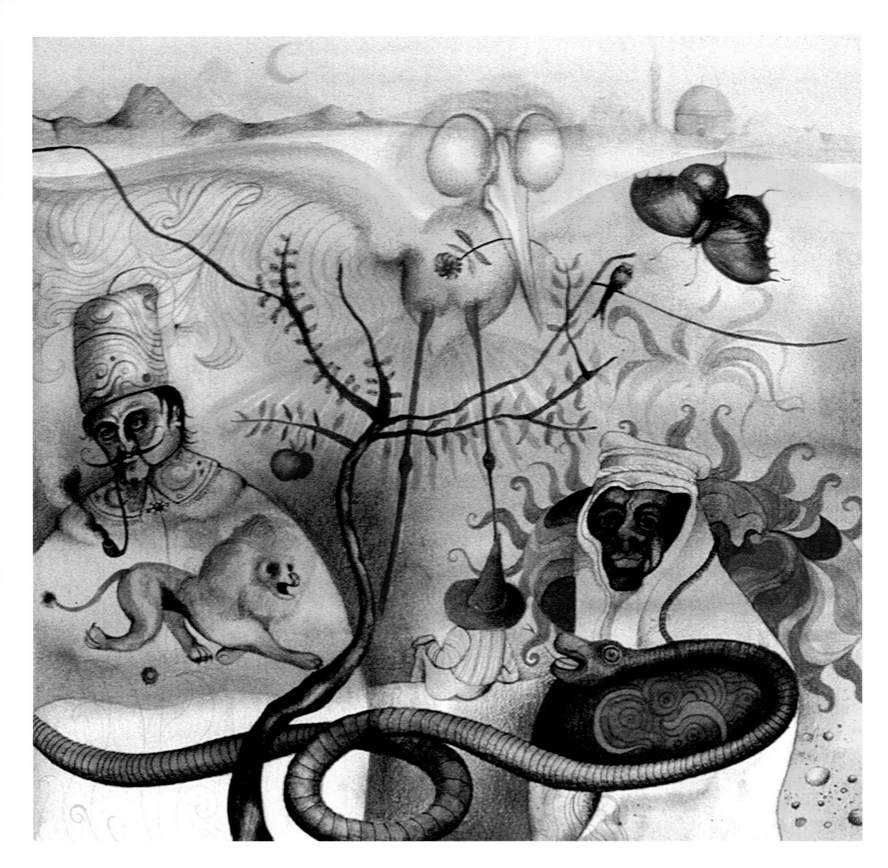

A once-born person sees only this world, but everyone who is born again from himself, that is, one who emerges from bondage to his human inclinations, will see the other world.

SHARAF AD-DIN MANERI

As the pupil within the eye, so is the Lord within the body. Foolish men recognise Him not, and they go searching without.

KABIR

All a seeker can do is wonder and marvel at the magnificence and diversity of God's creation.

MEISTER ECKHART

Association with the wicked produces suspicion of the good.

HASAN-AL-BASRI

Annihilate the enemy by discussion and captivate the heart of friends by hospitality.

BABA FARID

A hundred thousand beauties, appetites, passions, loves, views, courses of action, choices, falling in love, caressings of lovers, sorts of faculties, kinds of life, stratagems, ruses, embraces, kisses, sweet meetings ... God has pulled all of these over the face of nonexistence.

BAHA WALAD

Am I in the world or the world in me? Located in space or devoid of space? May Thee rejoice in Thy spacelessness. Pray tell me though, what is my place?

MUHAMMAD IQBAL

Ask that I may be forgiven if my pen has gone astray or my foot has slipped, for to plunge into the abyss of the divine mysteries is a perilous thing, and no easy task is it to seek to discover the unclouded glory which lies behind the veil.

ABU HAMID AL-GHAZALI

Always keep the doors of peace open in a war.

BABA FARID

Behind every rosebush of pleasure hides a rattlesnake of pain.

PARAMAHAMSA YOGANANDA

Beauty in the absolute sense of the word, belongs alone to the One who has no equal, the unique One who has no like, the Eternal to whom none is similar, the Rich who has no needs, the Omnipotent who does what He pleases and who judges as He will.

AL-GHAZALI

Between the doors of birth and death stands yet another door, wholly inexplicable. He who is able to be born at the door of death, is devoted eternally … Die before dying … Die living.

GOSAIN GOPAL

Before the throne of love, reason falls silent. Leave behind all words, all speech; each moment, each breath, is a treasure.

DR JAVAD NURBAKHSH

Beneath this world of stars and flowers that rolls in visible deity, I dream of another world of ours, and it is the soul of all we see.

AGNES DUCLAUX

Beauty and Love are as body and soul. Beauty is the mine, and Love the precious stone. They have always been together from the very first. They have always travelled in each other's company.

NURUDDIN ABDUR RAHMAN JAMI

But for my faith in God, I should have been a raving maniac.

MAHATMA GANDHI

Boast not of youth, wealth or kindred. Swifter than eyes can wink, each is stolen by Time.

SRI SHANKARACHARYA

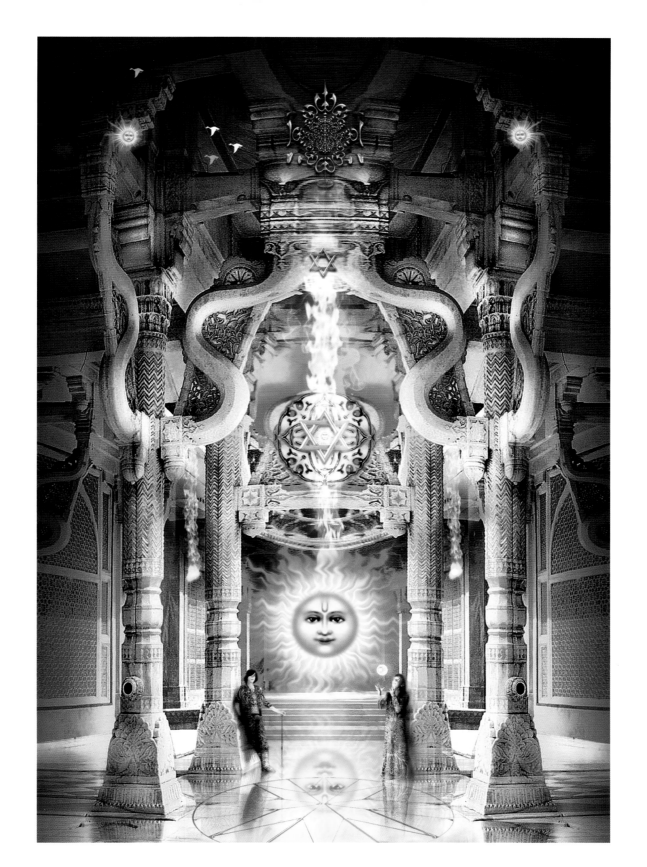

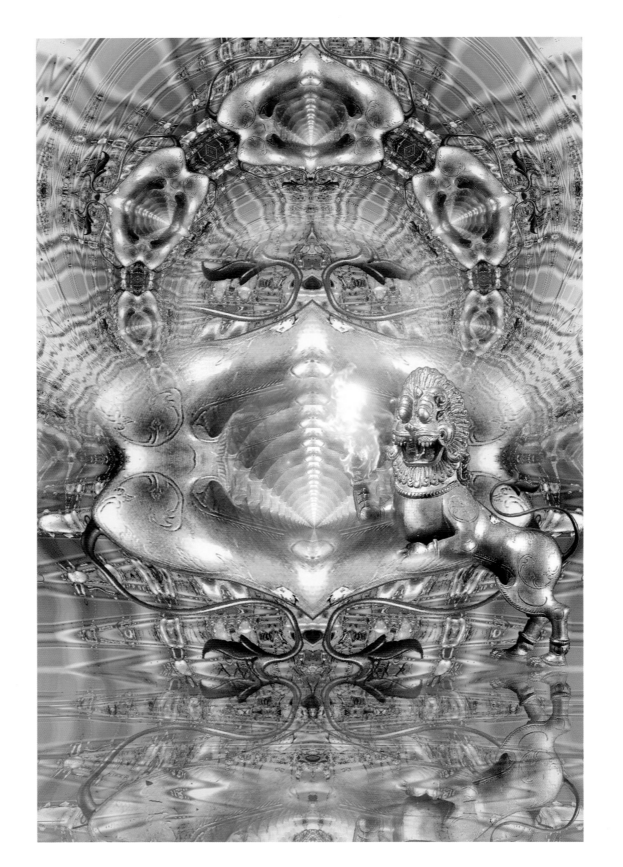

Birds in the air and fish in water dart and leave no track behind, and none can see the path pursued by those that journeyed towards and attained the Self.

SRI MURUGANAR

Better than a thousand-verse poem of empty sounds, is one stanza, which on hearing, brings one peace.

THE DHAMMAPADA

Be a captive of love in order that you may be truly free.

ABD AL-RAHMAN JAMI

Behind the veils He hides.

JAMI

Belong to your Lord and be His companion. Be a stranger to other things and other states. Keep your gaze upon your Sovereign. Whatever you want, ask it from Him. Rub yourself against Him. Mix with Him like milk and honey.

BAHA WALAD

Blind are they who lack faith in God, for man sees the Divine with the eyes of faith.

SATHYA SAI BABA

Be certain, in the religion of Love, there are no believers or unbelievers. Love embraces all.

RUMI

Come, take just a little of my heart's solitude, and build under the heavens an everlasting paradise. We have been on intimate terms since the day of creation, and are the high and low notes of the same song.

MUHAMMAD IQBAL

Containing all works, containing all desires, containing all tastes, encompassing this whole world, without speech, without concern, this is the Self of mine within the heart.

CHANDOGYA UPANISHAD

Cultivated people harmonise without imitating. Immature people imitate without harmonising.

CONFUCIUS

Conventional piety brings its rewards, a mansion in Paradise; but for a ragamuffin sinner like me,
a seat in the tavern is enough.

HAFIZ

Close your eyes and let the mind expand. Let no fear of death or darkness arrest its course. Allow the mind to merge with mind. Let it flow out along the great curve of consciousness. Let it soar on the wings of the great bird of duration, up to the very circle of eternity.

HERMES

Conceal a little spark of love in the cavern of your heart. How splendid is this world, you'll then realise.

FIRAQ GORAKHPURI

Do not take a step on the Path of Love without a Guide. I have tried it one hundred times and failed.

HAFIZ

Die to desire and you will live according to your nature.

PLATO

Don't be content with the outer scheme and semblance of the world,
for I am the Architect of your pavilion of contentment.

RUMI

Do not regret the past and do not worry about the future.

DHUN-NUN

Divine Unity is the return of man to his origin, so that he will be as he was before he came into being.

AL-JUNAYD

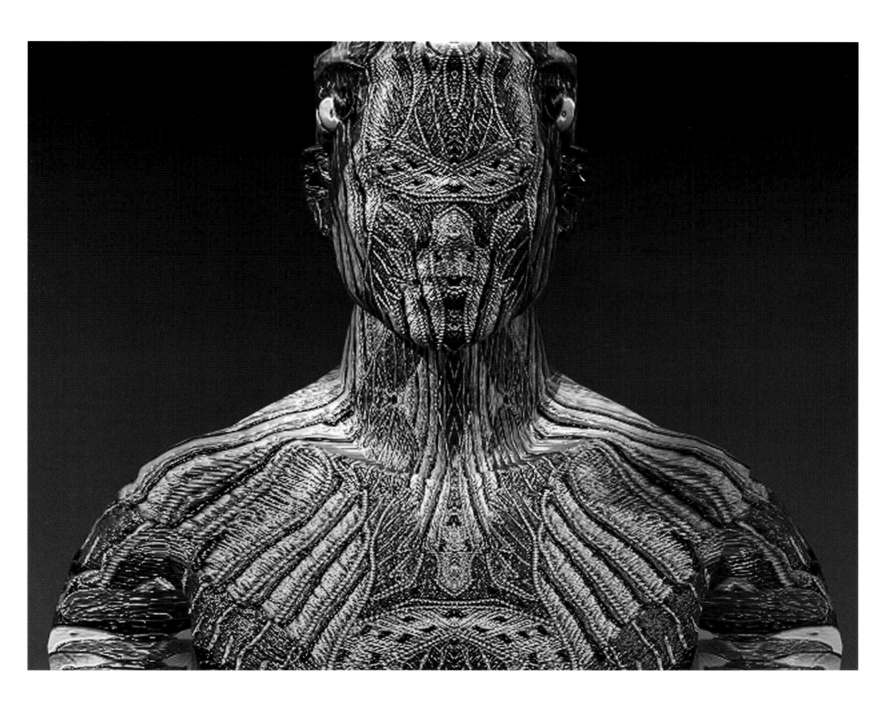

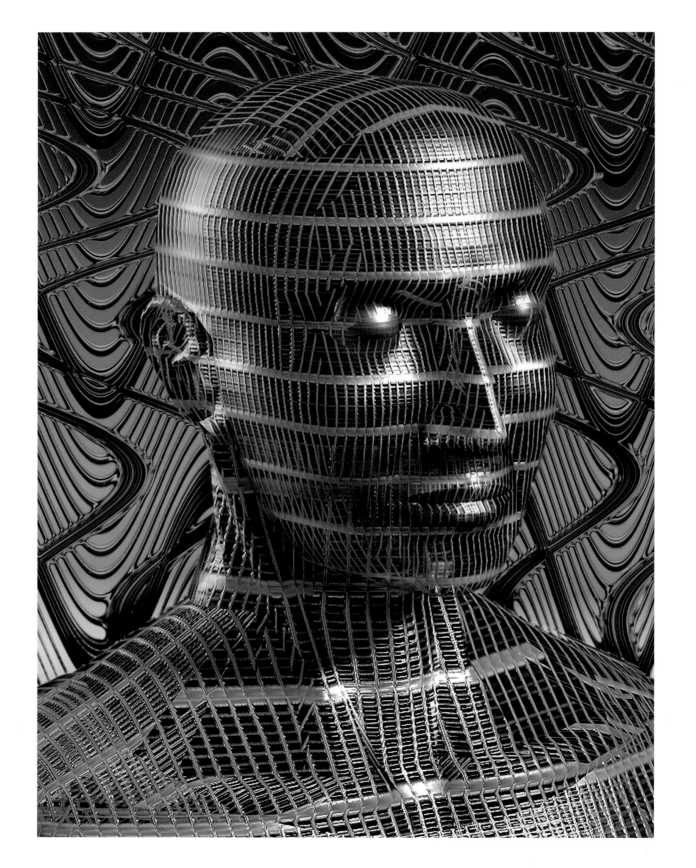

Down the ages the Great Masters have revealed to men what it is to be a Son of God, a being who radiates the light of wisdom and the power of love with a redeeming intensity.

HUGH FOUSSET

Do not look at my lowly nature; look at my aspiration.

FARID UL-DIN ATTAR

Do what is right at a given moment and then leave it behind.

RAMANA MAHARSHI

Deep in the sea are riches beyond compare, but if you seek safety, it is on the shore.

SA'DI

Each one has to find his peace within and for peace to be real, it must be unaffected by outside circumstances.

MAHATMA GANDHI

Everything started with the cry of the craving soul. Nourish me for I am hungry, and hurry for time is a sword.

RUMI

Every leaf in the book of Fate has two pages; one is written by man, the other by fate.

NIZAMI

Everyone in this world has to face happiness and sorrow, no matter who he is. But a worldly being starts lamenting when he gets pain, whereas the Saints don't bother; they bear the pain smilingly.

ASHUTOSH MAHARAJ

Deft though we are in breaking all idols, as long as We are, there's one more idol to break.

GHALIB

Everyone has faith in God though everyone does not know it. For everyone has faith in himself and that, multiplied to the nth degree, is God. We may not be God but we are of God, even as a little drop of water is of the ocean.

MAHATMA GANDHI

Enter the arena, armed with shield or quiver; Ascribe nothing to yourself; Abandon all with us. Let time bring what it will, hell or high water. Live joyfully, delighting in whatever comes your way.

ABU SA'ID

Even if a person hurts you, give him love. The worst punishment is to throw someone out of your heart. You should love everyone as God, and love each other. If you cannot love each other, you cannot achieve your goal.

NEEM KAROLI BABA

Exemplary people understand matters of justice; Small people understand matters of profit.

CONFUCIUS

Every ant which leaves its nest and goes to the desert, will see the sun, but not know what it sees. What irony! Everyone perceives Divine Beauty with certainty's eye, for in reality nothing exists but Transcendent Unity; they look, they see, but do not comprehend. They take no pleasure in the view, for to enjoy it one must know, through the Truth of Certainty, what he is seeing, through Whom, and why.

IRAQI

Eternity broods over every moment of love. A night of love is not a mere terrestrial night.

FIRAQ GORAKHPURI

Everyone seeks security of his faith but few seek love. I wonder in my heart that people care for faith but are shy of love, for faith has no clue of the station where love is able to lead.

SULTAN BAHU

Ever new, ever fresh is the Spring of Love.

BULLE SHAH

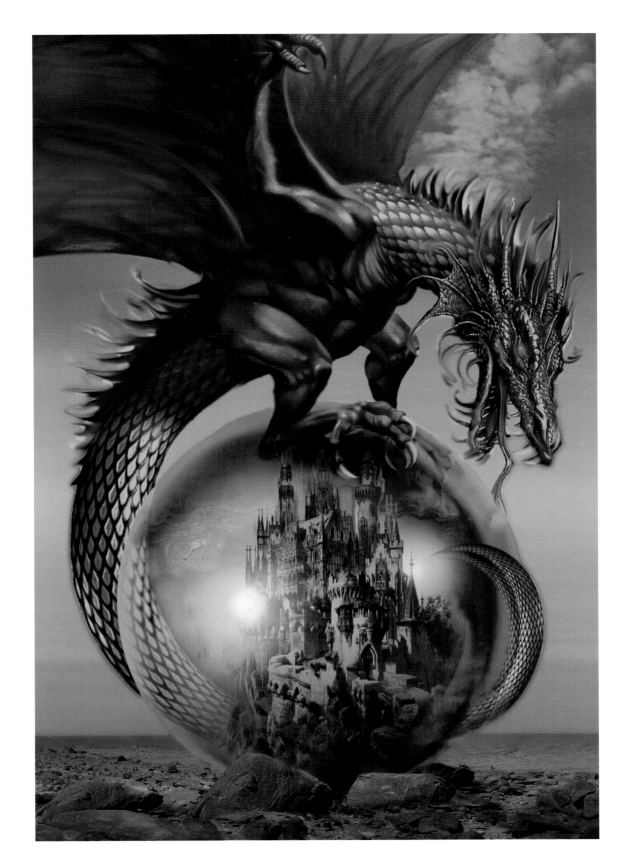

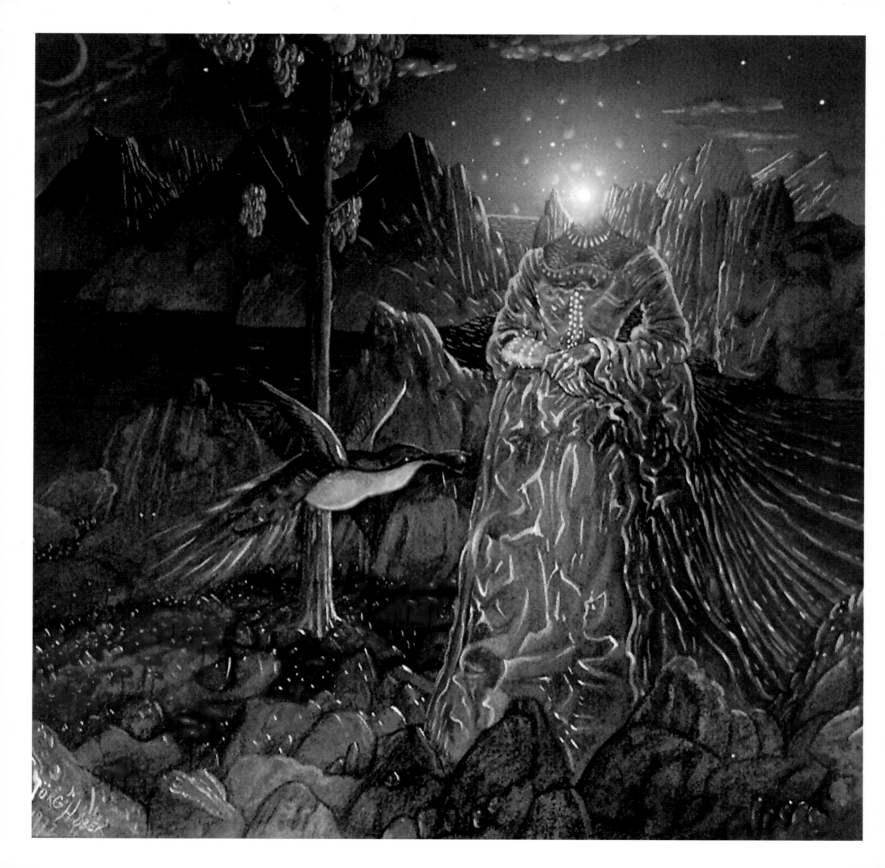

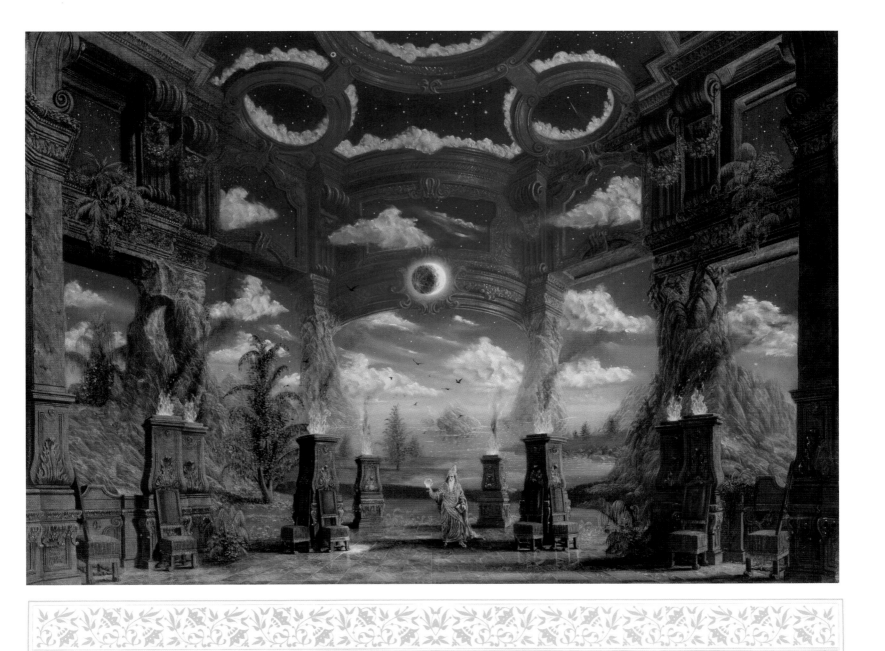

Who makes the sun rise and set regularly, and race across the sky every day? Who makes the stars that spangle the sky at night and vanish by day? Who makes the wind god sustain, without respite for a moment, billions of lives the world over? Who has made the bubbling brook that gurgles along its winding course for ever?

SATHYA SAI BABA

Eating honey makes you feel sweet, but what are you going to do when the honey runs out? Embrace Love and become honey.

RUMI

Ecstasy is the loss (of the Knowledge) of existing things and is the existence of lost things.

BABA TAHIR

Events happen, deeds are done, but there is no individual doer as such.

THE BUDDHA

Endure tears in the world that you might laugh in the next world.

HADRAT ABUL HASAN KHIRGANI

Forget not that your body contains the whole of existence.

GOSAIN GOPAL

Far more indispensable than food for the physical body, is spiritual nourishment for the soul. One can do without food for a considerable time but a man of the spirit cannot exist for a single second without spiritual nourishment.

MAHATMA GANDHI

Feel the Divine presence everywhere, see the Divine glory all around, then dive deep into the Divine source and realise the infinite bliss.

SWAMI SIVANANDA

For those who set their hearts on Me, and worship Me with unfailing devotion and faith, the way of Love leads sure and swift to Me.

SRI KRISHNA

Faith of consciousness is freedom. Faith of feeling is weakness. Faith of body is stupidity.

G I GURDJIEFF

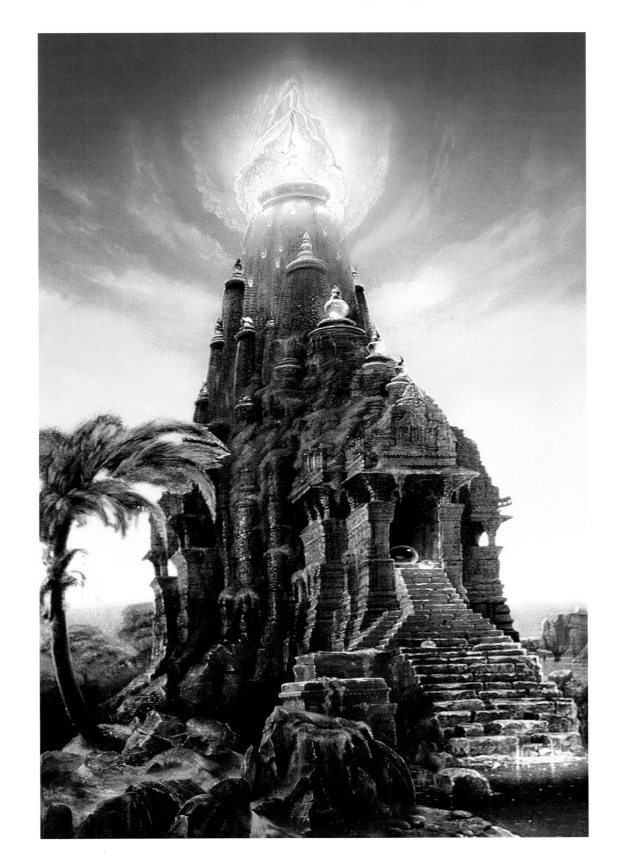

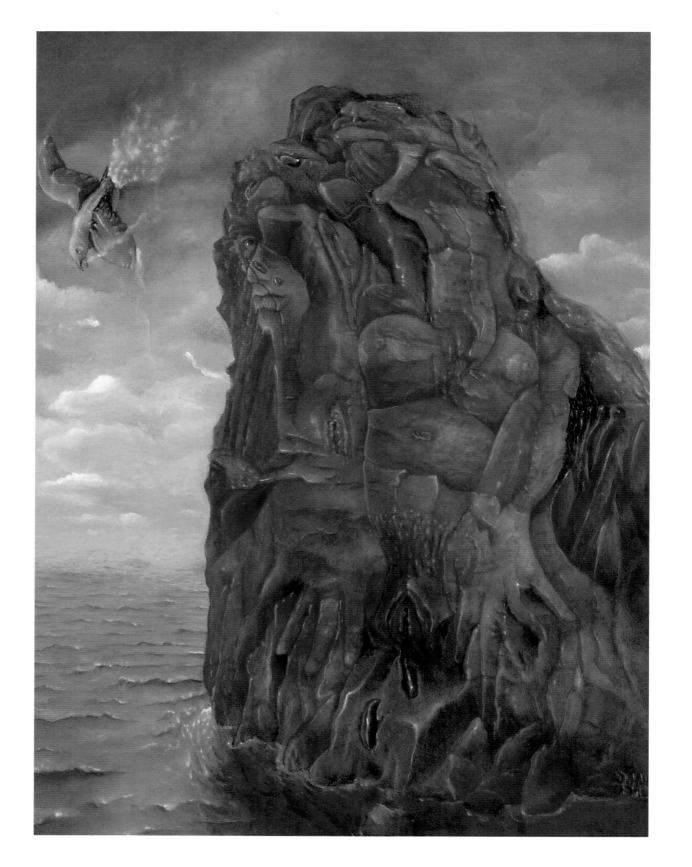

I found a raft made of snake in this Ocean of Existence. If I let go, I'll drown; if I hang on, it'll bite my arm.

 KABIR

Follow my ways and I will lead you to golden haired suns, logos and music, blameless joys, innocent of questions and beyond answers.

THOMAS MERTON

Fools who cannot grasp the truth, who cannot recognise divinity and measure the power of god, live in the delusion that their petty plans will save them and that they can triumph through their own efforts. The fact is that not even the smallest success can be won without God's grace.

SAGE SHUKA

Freedom exists for those willing to keep evolving. Clean your soul-mirror until it reflects the Light.

RUMI

God does not charge a soul with more than it can bear.

QUR'AN

God cannot be known except as a synthesis of opposites.

ABU SAID AL-KHARRAZ

God hides himself behind seventy thousand veils of light and darkness. If He took away these veils, the dazzling lights of His face would at once destroy the sight of any creature who dared look at it.

TRADITION

Get up, wake up! Seek the audience of an illumined teacher and realise the Self. Sharp like a razor's edge, the sages say, is the Path, difficult to traverse.

KATHA UPANISHAD

God creates out of nothing. "Wonderful" you say. Yes, to be sure, but He does what is still more wonderful; He makes saints out of sinners.

SOREN KIERKEGAARD

God stands between a man and his heart.

QUR'AN

Greater love has no man than this, that a man lay down his life for his Friend.

JOHN 15:13

Gather a shell from the strewn beach and listen at its lips. They sigh the same desire and mystery, the echo of whole sea's speech, and all mankind is thus at heart, not anything but what thou art; and earth, sea, man, are all in each.

DANTE GABRIEL ROSSETTI

Guarding speech, controlling mind, not doing wrong with the body, a man keeps the three avenues to action clear and thus finds the Path shown by the Wise.

THE DHAMMAPADA

Greater than the Great am I
While deep in the Great I lie,
Where whatever I should say
Meaningless my word would lay.
I see the wondrous sight
Inside the perfect light
Of our Lord of the Meeting Rivers.

BASAVA

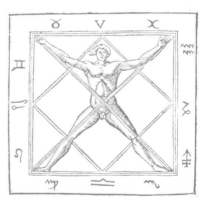

How can one reach the pearl by only looking at the sea? It takes a diver to reach the pearl.

RUMI

Grand are the doors of religions, narrow is the path of divinity.

SULTAN BAHU

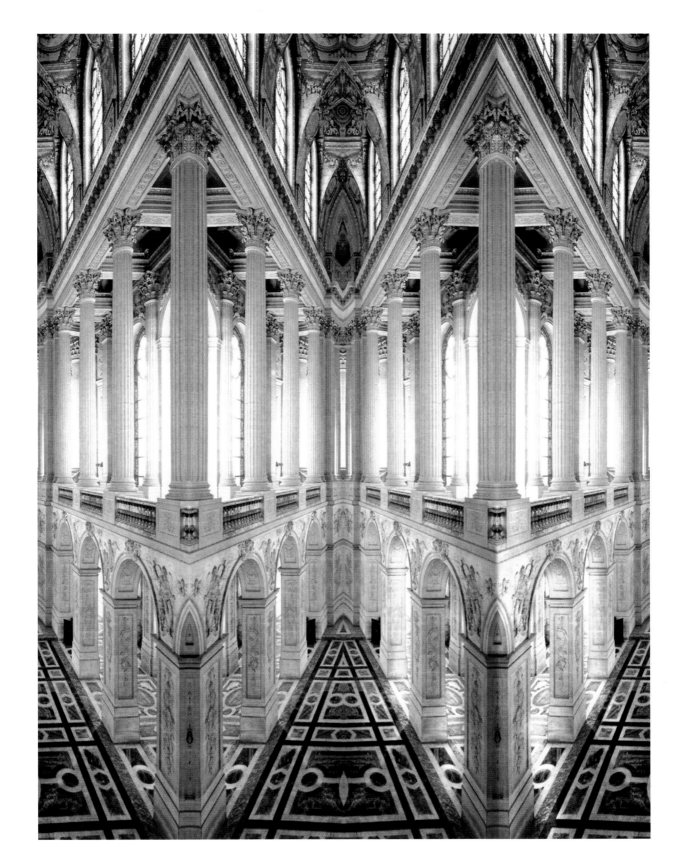

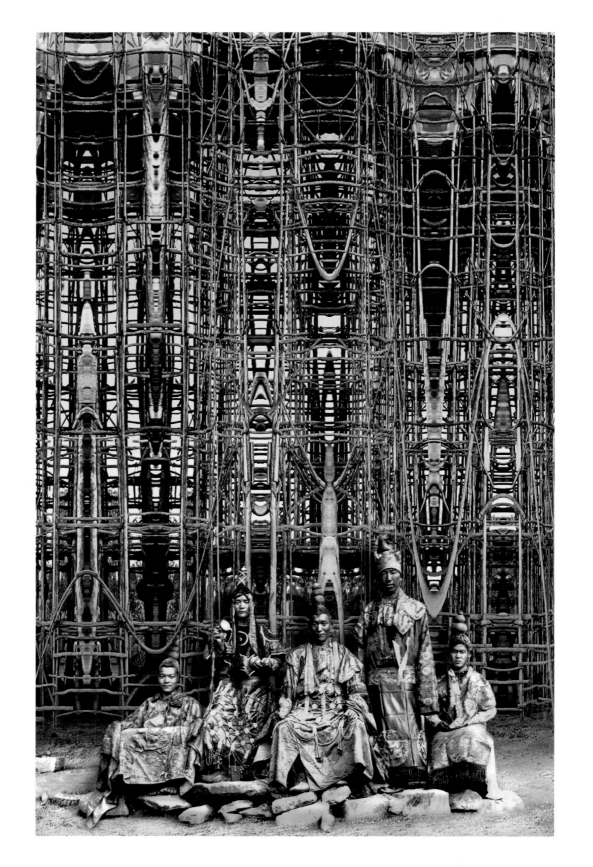

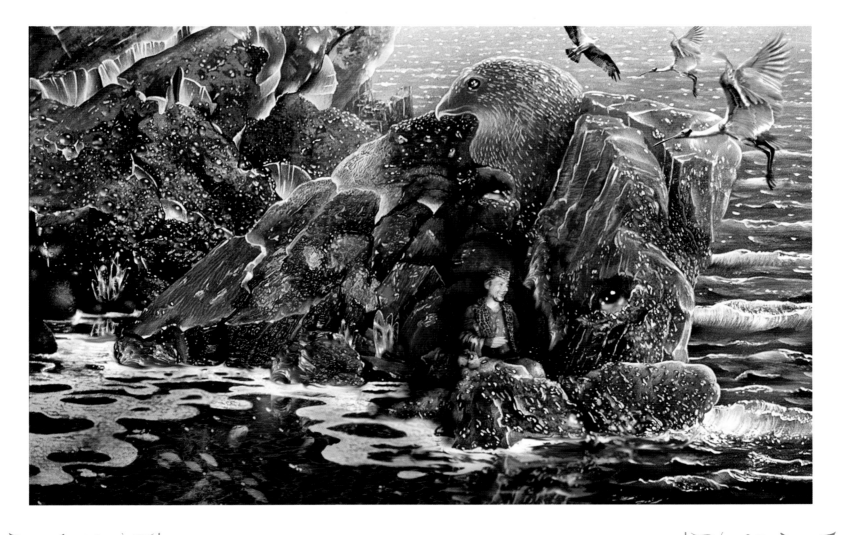

When you are thirsty and drink from a cup, it is God you see inside the water. The one who is not in love with God sees only his own image in the water.

RUMI

Who am I? Nothing but a dream, an image upon water. It is only through habit that you see me in my body.

DR JAVAD NURBAKHSH

He who knows himself, knows his Lord.

QUR'AN

He who learns nothing from the past, will be punished by the future.

THUS SPAKE ZARATHUSTRA

Heaven is the destination and the world is a path to cross. Both, to the enlightened, are no more than a blade of grass. If you are a true lover, ignore them both and pass, That the Friend Himself may give you the wine of union in a glittering glass.

ABU SAID ABI'L-KHAIR

Hold on to natural goodness and it will remain; let go of it and it will disappear. One never knows the time it comes and goes, neither does one know the duration.

CONFUCIUS

He saw the lightening in the East, and he longed for the East; but if it had flashed in the West, he would have longed for the West. My desire is for the lightening and its gleam, not for the places and the earth.

IBN ARABI

He who has knowledge possesses power. Knowledge gives an old heart a new flower.

RUMI

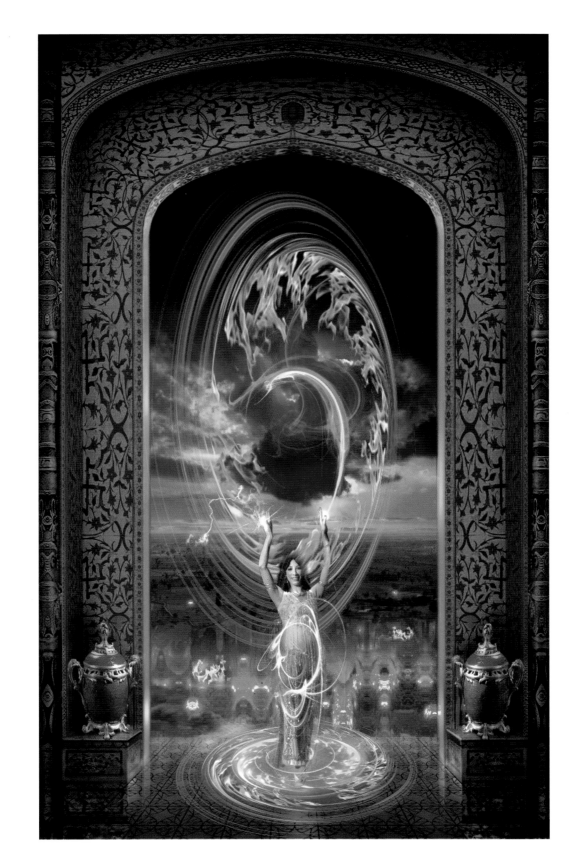

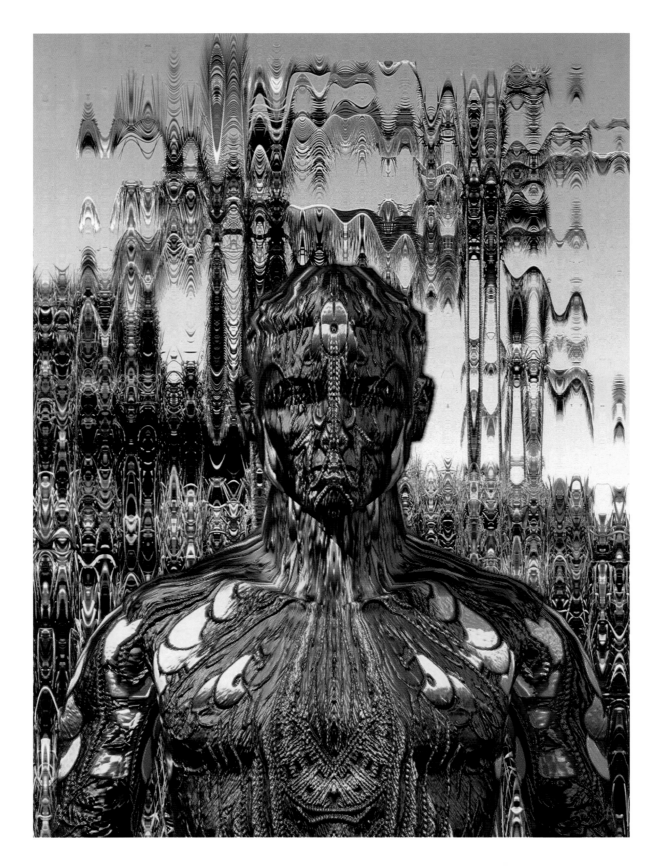

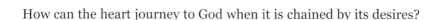

How can the heart journey to God when it is chained by its desires?

IBN ARABI

Half of what I say is meaningless; but I say it, so that the other half may reach you.

KAHLIL GIBRAN

He feels even the touch of an ant's foot; if a stone moves under water, He knows it. If there is a worm in a rock, He knows its body, smaller than an atom.

HAKIM SANAI

Heart to heart is an essential means of passing on the secrets of the Path.

RUDBARI

How sweet the moonlight sleeps upon this bank! Here will we sit, and let the sounds of music creep in our ears. Soft stillness and the night become the touches of sweet harmony.

WILLIAM SHAKESPEARE

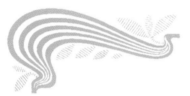

Higher yet and higher, out of clouds and night,
Nearer yet and nearer, rising to the light.
Light, serene and holy, where my soul may rest,
Purified and lowly, sanctified and blessed.

GOETHE

He is wise who beholds the three worlds as but parts of himself, rolling about in him like waves of the sea.

YOGA VASISHTHA MAHARAMAYANA

Hidden in the heart of every creature exists the Self, subtler than the subtlest, greater than the greatest.

KATHA UPANISHAD

Holiness within and selfless action without.

MARCUS AURELIUS

He who sees Me everywhere and sees all in Me, I am not lost to him nor is he lost to Me.

SRI KRISHNA

It is in the realm of the soul that we find the heavens which govern the skies of the world.

SANA'I

In myself, there is nothing of mine. All there is, is Thine. Whatever I offer Thee, is Thine already. How can the gift be mine?

KABIR

How long, I asked, is the life of a rose? The bud replied with just a smile.

MIR TAQI MIR

He created for me an eye out of his Light, and I saw all creatures through God.

ABU YAZID BASTAMI

He is in my heart and my heart is in His hand.

GAUTH ALI SHAH

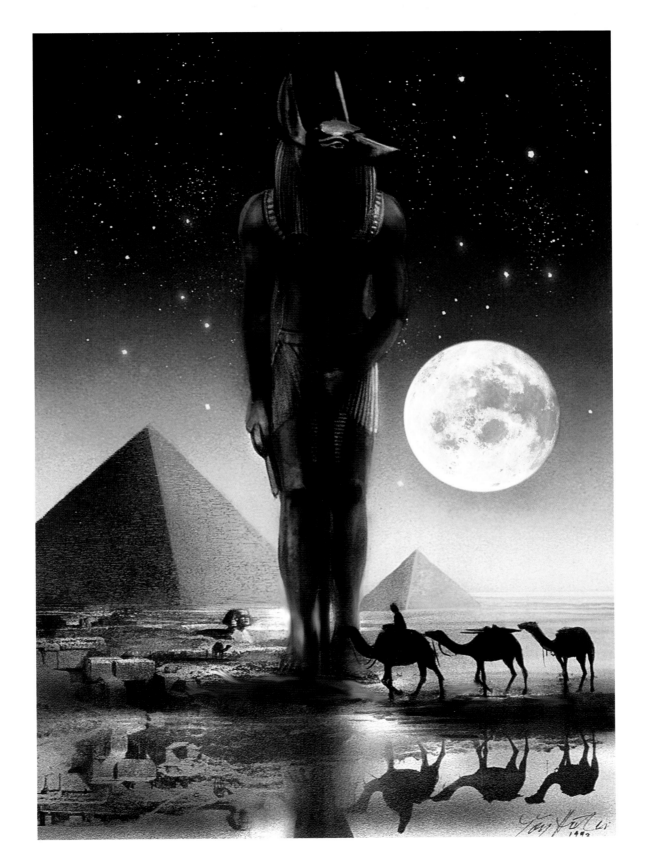

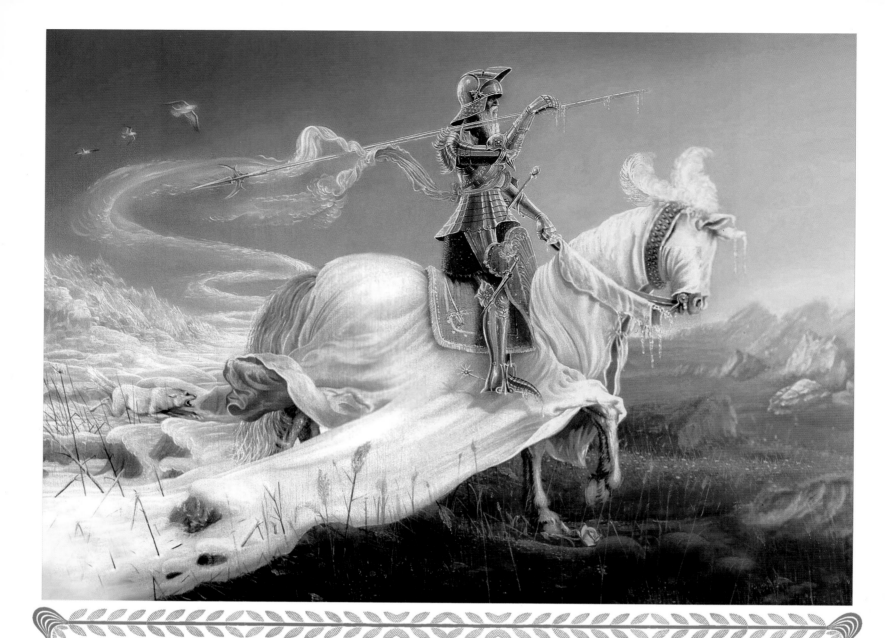

I have learnt silence from the talkative, toleration from the intolerant, and kindness from the unkind; yet strange, I am ungrateful to these teachers.

KAHLIL GIBRAN

Though you read a hundred volumes without a pause, you won't remember a single point without the Divine decree; but if you serve God and never read a single book, you'll learn rare sciences within your own heart.

RUMI

If I look at the clouds in the sky, I see His beauty afloat; and I see Him walk on the stars, blazing my heart.

FIKIRCHAND

If you wish to hold the moon in your hands, clip the noose around your neck and worship Love.

GOSAIN GOPAL

If you fail to recognise your own heart, can you ever come to know the Great Unknown?

KALACHAND

I made the seven seas my ink and all the trees of the forest my pen, and the whole expanse of the earth my paper, but still I could not write the greatness of God.

KABIR

In order to arrive at having pleasure in everything
Desire pleasure in nothing
In order to arrive at possessing everything
Desire to possess nothing
In order to arrive at being everything
Desire to be nothing
In order to arrive at the knowledge of everything
Desire to know nothing.

ST JOHN OF THE CROSS

It is no more surprising to be born twice than once.

VOLTAIRE

If He closes before you all the ways and passes, He will show you a hidden path which nobody knows.

RUMI

I will not serve God like a labourer, in expectation of my wages.

RABI'A

I will lead you by a way you do not know, to the secret chamber of Love.

ST JOHN OF THE CROSS

In the state of collectedness, the single beings of the world are one. All the petals of the rose together are One.

KHWAJA MIR DARD

I died as a mineral and became a plant. I died as plant and rose to animal. I died as animal and I was a man.
Why should I fear? When was I less by dying? Yet once more I shall die as man, to soar with angels blest. But even from
angelhood I must pass on, for all except God perishes, and when I have sacrificed my angel soul, I shall become
what no mind ever conceived.

RUMI

I went through the thick forests of perpetual desire.
I crossed the running rivers of longing.
I passed through the descent of silent suffering.
I climbed the steep hills of continual strife.
Feeling ever some presence in the air I asked,
"Are you there, my love?"
And a voice came to my ears saying,
"No, still further am I".

HAZRAT INAYAT KHAN

If you love the Eternal and I love the Eternal, then we love the same thing, so we are all lovers of one another.

TRADITION BAUL

If a man's ecstasy is weak, he exhibits ecstasy. If, however, his ecstasy is strong, he controls himself and is passive.

ABU BAKR AL-KALABADHI

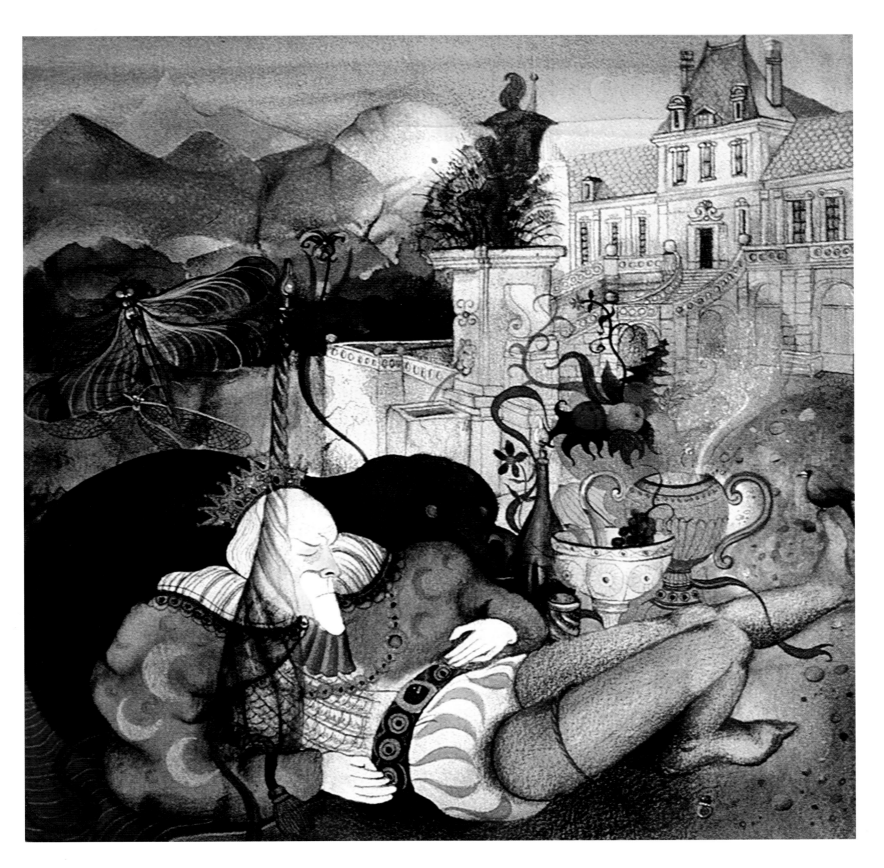

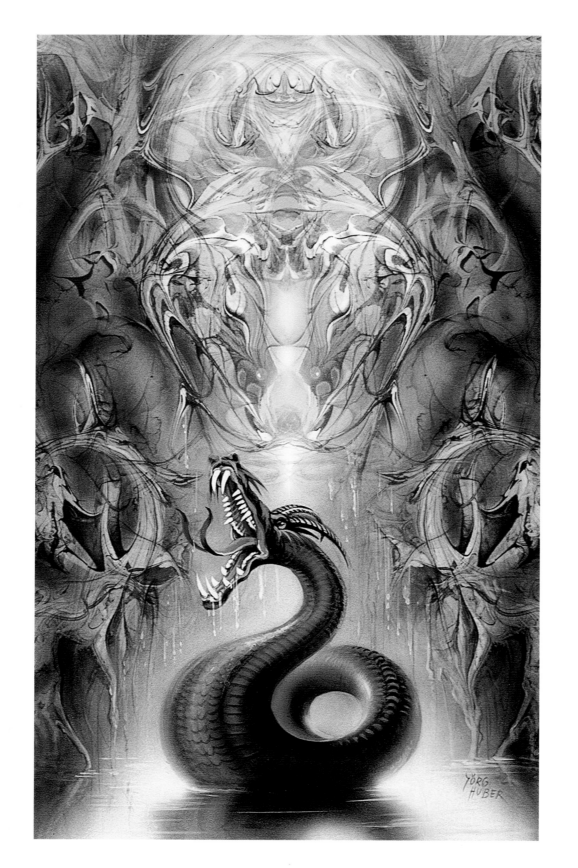

I think it not improbable that Man, like the grub that prepares a chamber for the winged thing it has never seen but is to be, that Man may have cosmic destinies that he does not understand.

JUSTICE OLIVER WENDELL HOLMES

If the Way is made clear, it is no longer the Way.

CHUANG-TZU

It is better to restore one dead heart to eternal life than life to a thousand dead bodies.

PIR MURAD

I marvelled at an ocean without shore and a shore without ocean,
At a morning light with no darkness, and a night with no dawn,
At a sphere without any location known to pagans or priests,
At an azure dome, raised high, revolving, all-compelling power its centre,
And at a rich earth without dome or location, the Mystery concealed.

IBN ARABI

I am too alone in the world, and not alone enough, to make every minute holy.

RILKE

I have held my soul in peace and in silence, as a child in it's mother's arms.

CARLO CARRETTO

In a world where reason and faith exist, death of the body is birth of the soul.

BORHAN AL-DIN MOHAQQEQ

If you make a mistake and do not correct it, it is called a mistake.

CONFUCIUS

In the beginning, nothing comes
In the middle, nothing stays
At the end, nothing goes
Of the mind, there is no arising and extinction.

MILAREPA

If you do not know a man, look at his friends; if you do not know a ruler, look at his attendants.

XUNZI

If you reveal your secrets to the wind, you should not blame the wind for revealing them to the trees.

KHALIL GIBRAN

In the death of the Self lies the life of the heart.

AL-SADIQ

In the morning, the ignorant man considers what he will do, while the intelligent man considers what it is God will do with him.

IBN 'ATA'ILLAH

In this world, there is no greater religion than the religion of Love.

SATHYA SAI BABA

I have realised that which is within me, and my tongue has conversed with You in secret. We are united in one respect, but we are separated in another. Although awe has hidden You from the glances of my eye, ecstasy has made You near to my innermost parts.

AL-JUNAYD

I may live without air and water but not without Him. You may pluck out my eyes but that cannot kill me. You may chop off my nose but that will not kill me. But blast my belief in God, and I am dead.

MAHATMA GANDHI

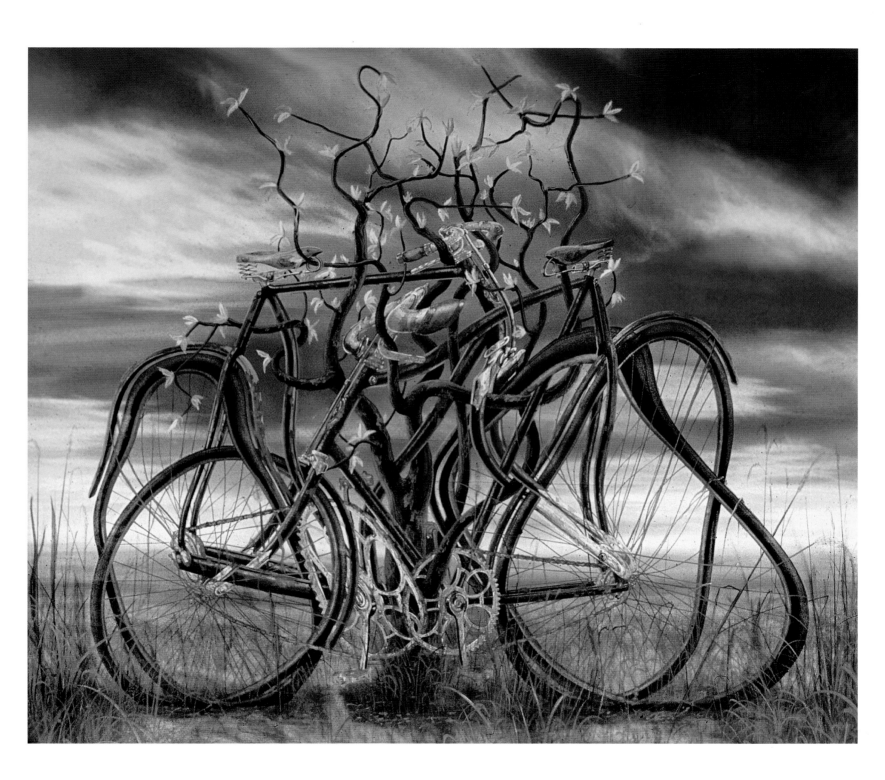

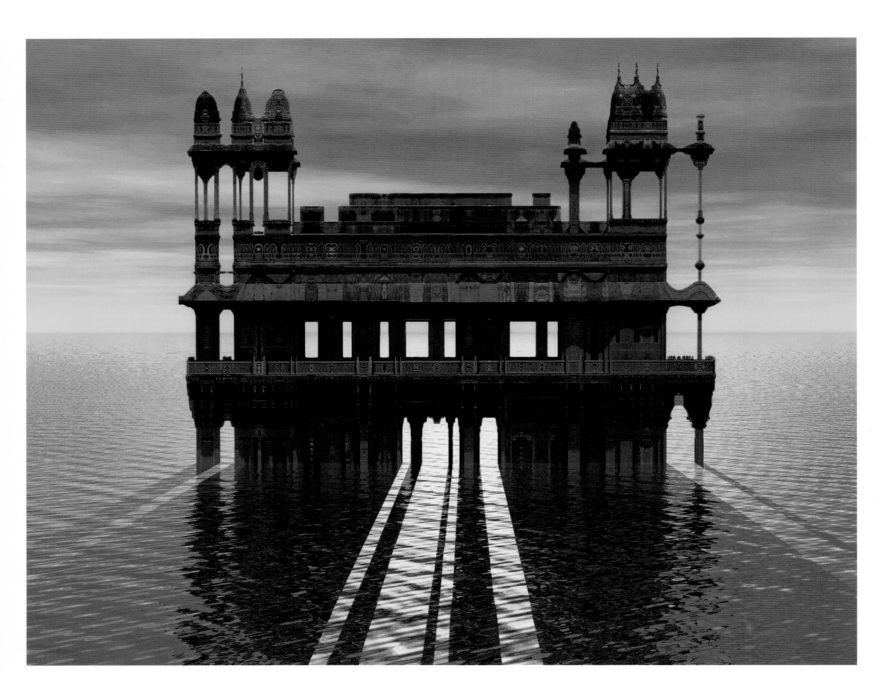

It is the power of Love that is responsible for the earth to rotate without a pivot. It is the power of Love that makes the stars stand across the sky without falling on the ground. It is the power of Love that keeps the oceans within their limits. It is the power of Love that makes the wind blow incessantly in all the worlds. That power of Love is mysterious, infinite, most wonderful, and one without a second; it permeates the entire cosmos. The entire creation is saturated with Love.

TELEGU POEM

If people were to meditate on the majesty of God, they would not be disobedient towards Him.

BISHR AL-HAFI

I long for Eternity because there I shall meet my unwritten poems and my unpainted pictures.

KHALIL GIBRAN

If perfume from the rose garden of Unity comes to me, my heart like a rose bud, will burst its outer skin.

KHWAJA HAFIZ

I am mad with love and no one understands my plight. Only the wounded understand the agonies of the wounded, when a fire rages in the heart.

MIRABAI

I follow the religion of Love: whatever way Love's camels take, that is my religion and my faith.

IBN ARABI

I remember the cornfields, and a dream of Oneness with all mankind, that was stretched out across the land, like rustling links in a golden chain.

HERMES

If you can't smell the fragrance, don't come into the garden of Love. If you're unwilling to undress, don't enter into the stream of Truth.

RUMI

It is by veiling itself a little, the sun can be better contemplated.

IBN SINA

In the world, men of insight may discern a stream whose currents swirl and surge and churn, and from the force that works within the stream, the hidden working of the Truth may learn.

NARUDDIN ABDUR RAHMAN JAMI

In truth, those are alive who have escaped the bondage of the flesh as from a prison, while that which you call life, is in reality, death.

CICERO

I have sought to come near You. I have called to You with all my heart, and when I went out towards You, I found You coming towards me.

JUDAH HALEVI

If towards the Lord you take a single step, then with much more than a mother's love, he takes nine steps towards you, to accept you. Such is the Guru's grace.

SRI MURUGANAR

I will not keep silent nor cease from urgent prayer till Your grace returns, and my heart leaps at the sound of Your voice.

THOMAS A KEMPIS

In the turbid waters of painful existence, innumerable beings cry out and groan. If, hearing them, your spirit does not shiver, your heart cannot be considered human.

LOSANG KALSANG GYATSO

It is the destiny of unbelievers not to believe in destiny.

RUMI

If you would indeed behold the spirit of death, open your heart wide unto the body of life. For life and death are one, even as the river and the sea are one.

KAHLIL GIBRAN

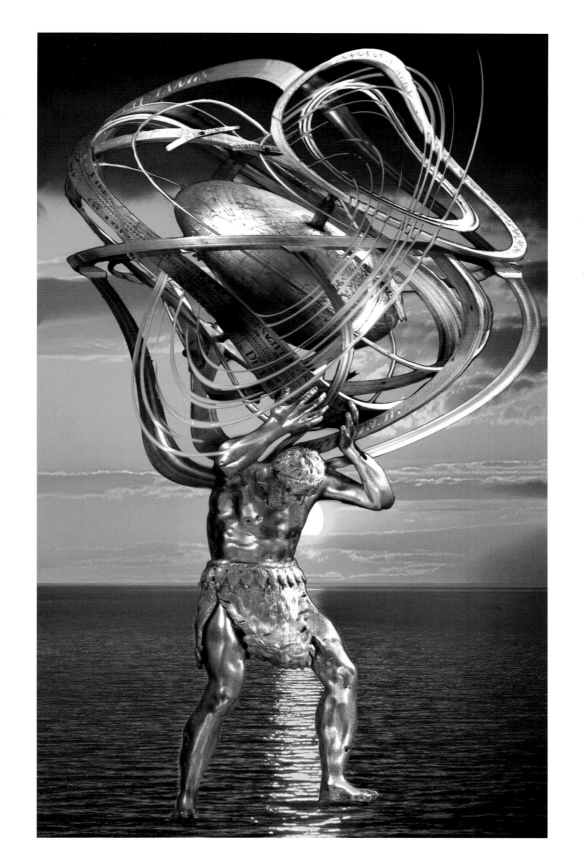

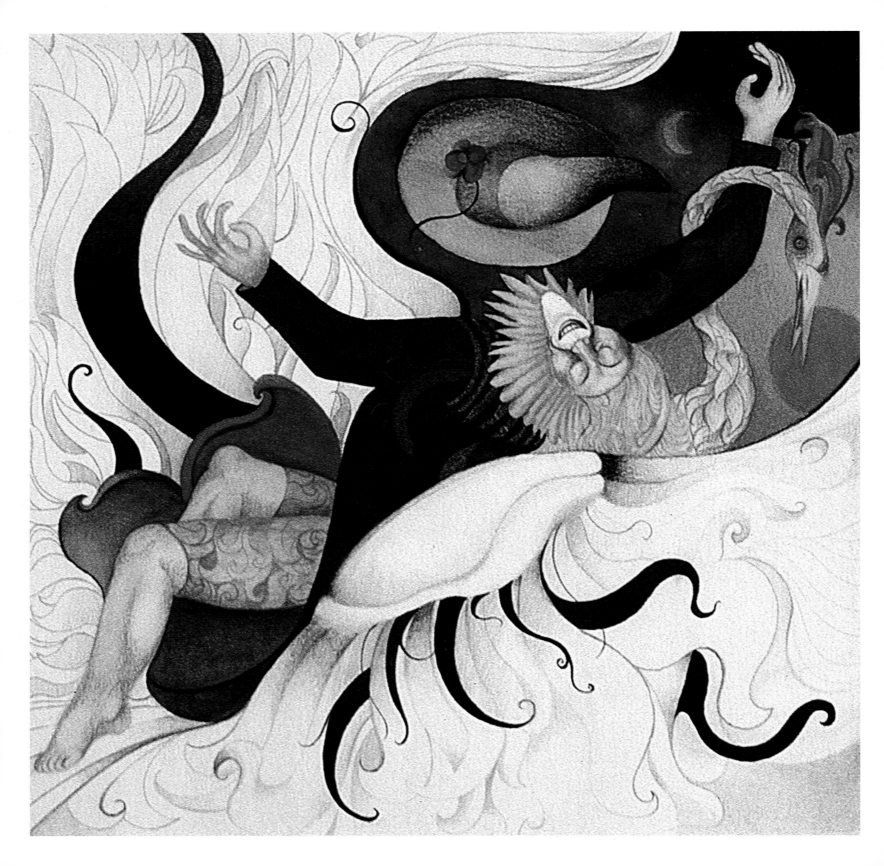

In humility is the greatest freedom.

THOMAS MERTON

If one can only realise at heart what one's true nature is, one then will find that it is infinite Wisdom, Truth and Bliss, without beginning and without an end.

RAMANA MAHARSHI

I hold that when a person dies,
His soul returns again to earth.
Arrayed in some new flesh-disguise,
Another Mother gives him birth.
With sturdier limbs and brighter brain,
The old soul takes the road again.

JOHN MASEFIELD

If you want peace of mind, do not find fault with others. Rather learn to see your own faults.

SRI SARADA DEVI

If you're not a tongue of God then be an ear.

RUMI

If you want to be a pilgrim on the Path of Love, the first condition is that you become as humble as dust and ashes.

ANSARI OF HERAT

In the One, there is the All. In the All, there is the One. If you know this,
you will never worry about being incomplete.

SENG TS'AN

It is better to live like a swan for two years than to live like a crow for a hundred years.

SATHYA SAI BABA

I am the falcon of the spirit world
Escaped out of the highest heaven
Who, out of desire of the hunt,
Am fallen into earthly form.

RALPH WALDO EMERSON

In ancient days, so I've heard tell, stone would turn to silver in the hands of Saints. You will not think such words unreasonable: when you're but content, silver and stone are One.

SA'DI

If, in the darkness of ignorance, you don't recognise a person's true nature, look to see whom he has chosen for his leader.

RUMI

I seek the Lord of the House; what have I to do with the House?

RABIA AL-ADAWIYA

It is God who made the world and endowed it with existence. The entire universe is therefore supremely beautiful.

IBN ARABI

Invisible, formless and untenable is the Creator. He is One with all, and all are One in Him. Whether manifest or hidden, He is all pervading.

MALIK MUHAMMAD JAISI

If you know you're alive, find the essence of Life. Life is the sort of guest you don't meet twice.

KABIR

It is evident truth that the Supreme is everywhere and yet nowhere.

PLOTINUS

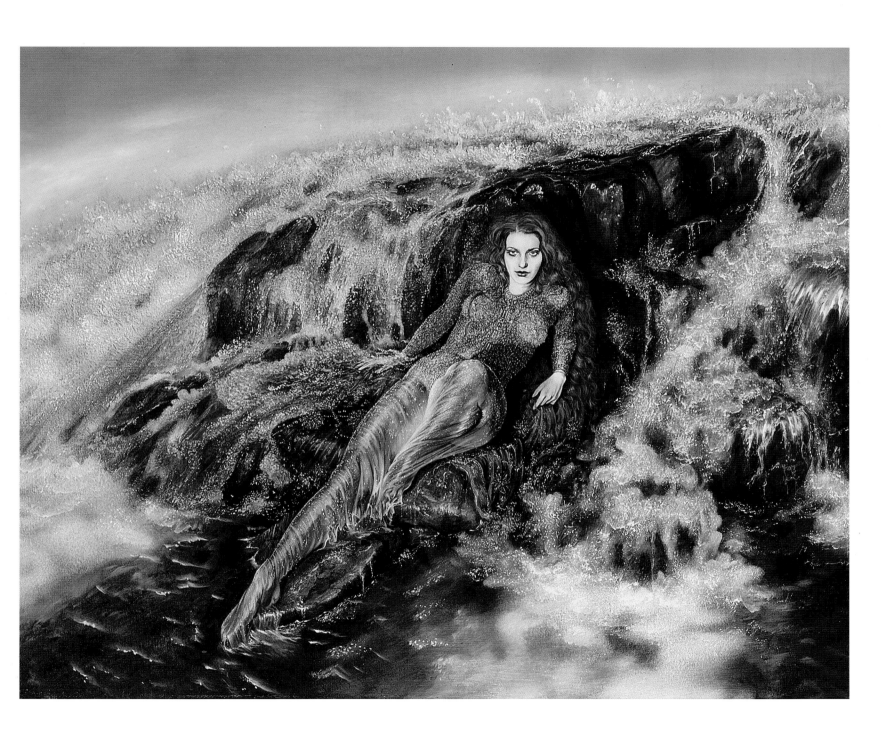

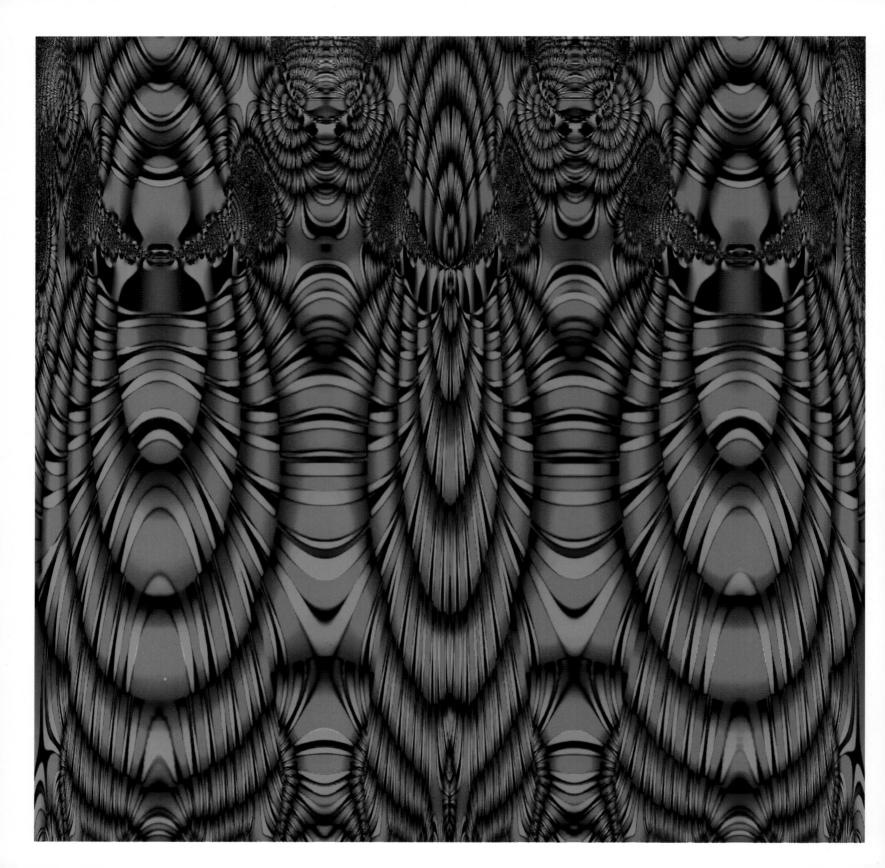

If you want your happiness to be everlasting, serve the Everlasting.

BAHA WALAD

In one sense we are always travelling, and travelling as if we did not know where we were going. In another sense we have already arrived.

THOMAS MERTON

If your spirit is dissolved in the flames of Love, you will see that Love is the Alchemy for your Spirit.

AHMAD HATIF OF ISFAHAN

If men wish to draw near to God, they must seek him in the hearts of men.

ABU SAID ABI'L-KHAYR

If you think of roses, you are a rose garden. If you think of thorns, you're fuel for the furnace.

RUMI

Joy and pain have the same shape: You can call the Rose an open heart, or a broken heart.

MIR DARD

Know that Knowledge is life, Wisdom a mirror, Contentment a Fortification, Hope is divine intercession, Recollection of God is a medicine, and Repentance is an antidote for all ills.

ABDULLAH ANSARI

Kindle the light of love in your heart. Include all creatures in the embrace of your love. Develop cosmic love and shed tears of love.

SWAMI SIVANANDA

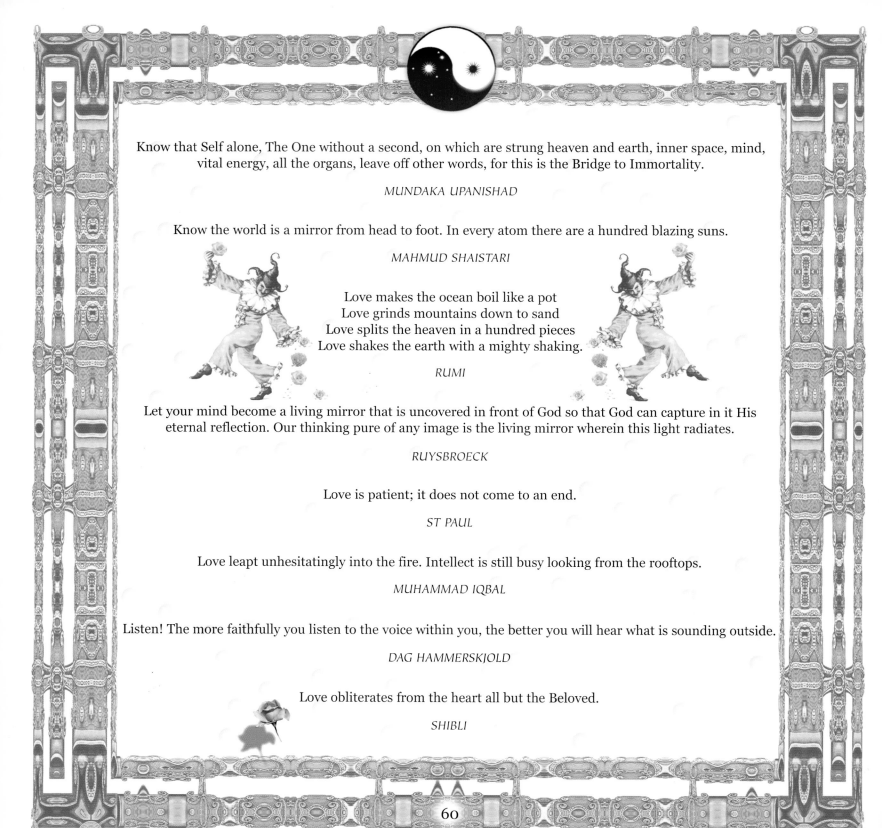

Know that Self alone, The One without a second, on which are strung heaven and earth, inner space, mind, vital energy, all the organs, leave off other words, for this is the Bridge to Immortality.

MUNDAKA UPANISHAD

Know the world is a mirror from head to foot. In every atom there are a hundred blazing suns.

MAHMUD SHAISTARI

Love makes the ocean boil like a pot
Love grinds mountains down to sand
Love splits the heaven in a hundred pieces
Love shakes the earth with a mighty shaking.

RUMI

Let your mind become a living mirror that is uncovered in front of God so that God can capture in it His eternal reflection. Our thinking pure of any image is the living mirror wherein this light radiates.

RUYSBROECK

Love is patient; it does not come to an end.

ST PAUL

Love leapt unhesitatingly into the fire. Intellect is still busy looking from the rooftops.

MUHAMMAD IQBAL

Listen! The more faithfully you listen to the voice within you, the better you will hear what is sounding outside.

DAG HAMMERSKJOLD

Love obliterates from the heart all but the Beloved.

SHIBLI

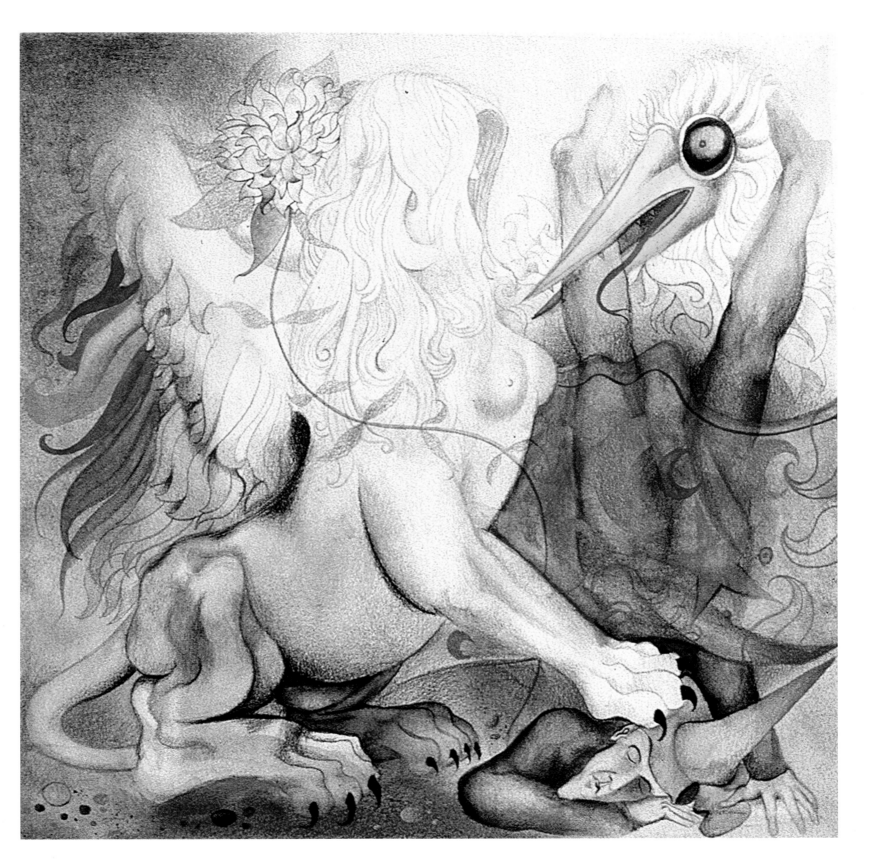

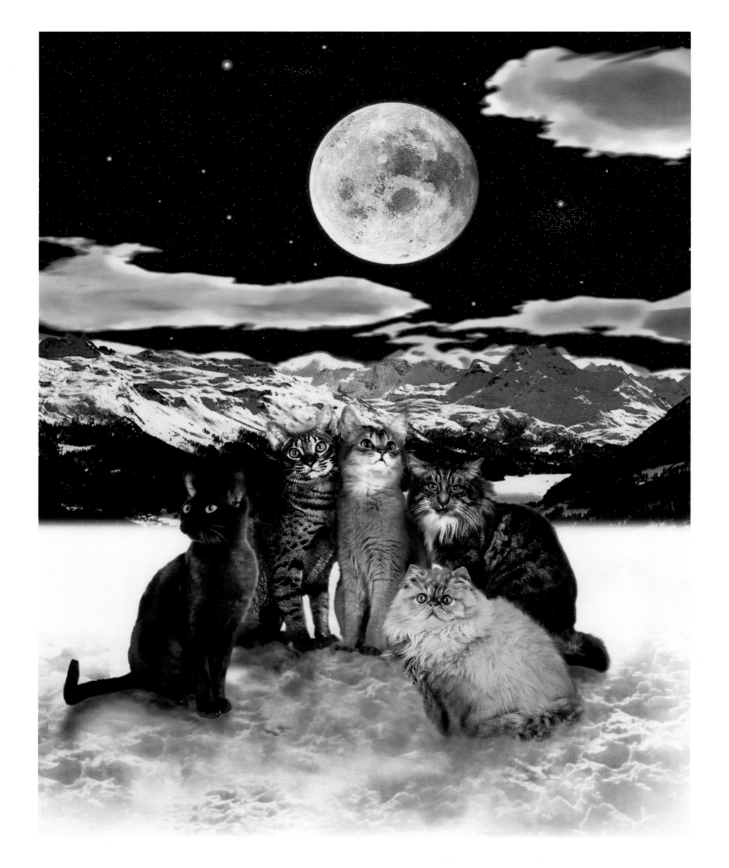

Lionhood is to keep back the sigh. To sigh is the work of foxes and sheep.

MUHAMMAD IQBAL

Life and death are one, even as the river and the sea are one. In the depth of your hopes and desires, lies your secret knowledge of the beyond.

KAHLIL GIBRAN

Like the tree remaining in the seed, so unseen remains the Lord, in every being on earth.

KABIR

Love with the fickle minded is like a thin stream descending from a height: it flows freely and froths much, but soon announces its exhaustion.

MIRABAI

Lead me from the unreal to the real
Lead me from darkness to light
Lead me from death to immortality.

BRIHADARANYAKA UPANISHAD

Love is higher than the highest. Love is greater than the greatest. In a certain sense, it is greater than God. In the highest sense of all, God is love and love is God.

JACOB BOEHME

Let brotherhood with every being on earth be the highest aspiration of your order.

GURU NANAK

Let me ever worship those compassionate Guardians who unceasingly protect and point out the pathway leading to the Sacred Flame.

HERMES

Lives of great men all remind us we can make our lives sublime, And departing, leave behind us footprints on the sands of time.

HENRY LONGFELLOW

Love is the world's sanctuary, the source of all justice, even if it waylays the intellects of man and woman.

RUMI

If knowledge does not liberate the Self from the Self, then ignorance is better than knowledge.

SANA'I

Let your love flow outward through the universe; to its height, its broad extent, a limitless love, without hatred or enmity.

SUTTA NIPATA

Life is a pilgrimage, where man drags his feet along a rough and thorny road. With the name of God on his lips, he will have no thirst; with the form of God in his heart, he will have no exhaustion. Each life is like a day's march on the pilgrimage; make the fullest use of your talents and march forward to pitch the tent nearer to the goal when darkness falls. Do not waste a single moment.

SATHYA SAI BABA

Let your soul stand cool and composed before a million universes.

WALT WHITMAN

Life behind the mask of light is turning on its toes and the magic spell of midnight continues to grow. How much time remains till the end of war?

FIRAQ GORAKHPURI

Love has organised this show; a great director is He. Every thing that lives and breathes is by Love conceived.

MIR TAQI MIR

Let me bathe my soul in colours, let me swallow the sunset and drink the rainbow.

KAHLIL GIBRAN

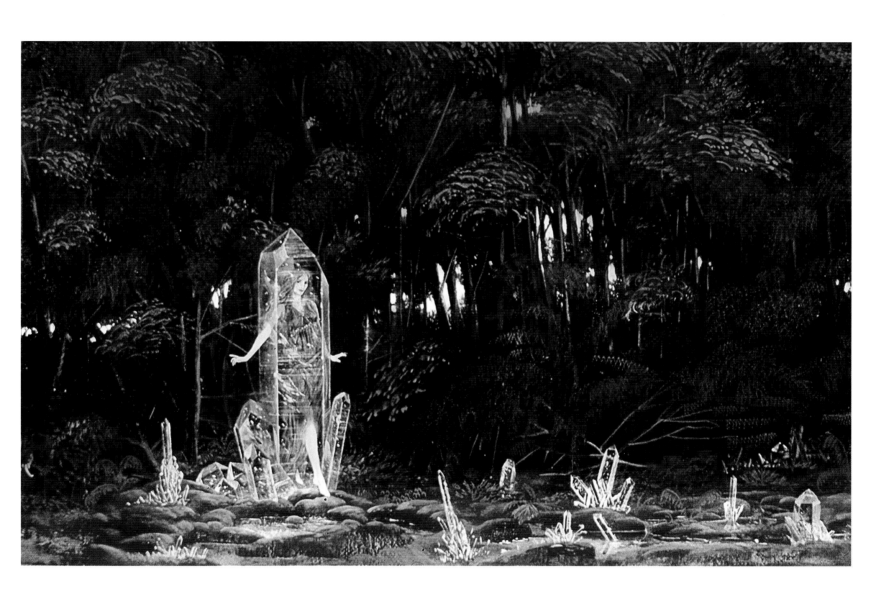

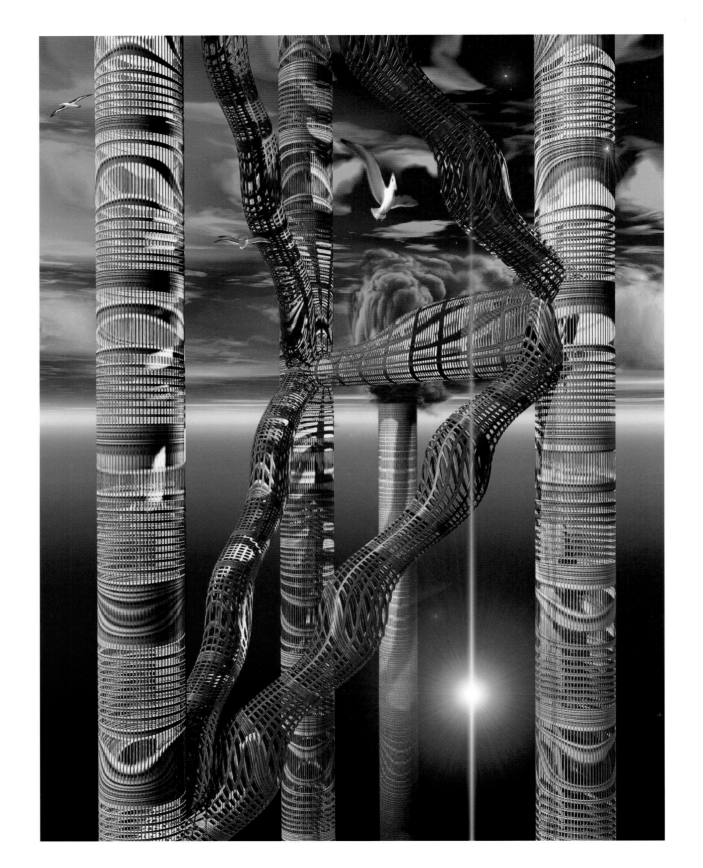

Love has no other desire but to fulfil itself.

KAHLIL GIBRAN

Love Him who loves you more than you love Him.

HADRAT ABDULLAH MANAZIL

Lamps are many but the light is One
Cows are many but the milk is One
Jewels are many but the gold is One
Nations are many but the earth is One
Waves are many but the sea is One
Stars are many but the sky is One
Beings are many but the breath is One.

SATHYA SAI BABA

Like a child sent with a fluttering light, to feel his way along a gusty night, Man walks the world.

FARID UL-DIN ATTAR

Love is that flame which, when it blazes up, consumes everything else but the Beloved.

RUMI

His Lord revealed to him the Mountain and made it in a moment dissolve into dust.

QUR'AN

Lover, Love and Beloved are all One.

KHWAJA MUINUD-DIN

Let the eye of your heart be opened that you may see the spirit and behold invisible things. If you set your Face towards the region where love reigns, you will see the whole Universe laid out as a rose garden.

AHMAD HATIF OF ISFAHAN

Let us drown ourselves in the Ocean of non-existence and come out cloaked with the garment of divine existence.

HADRAT ABUL HASAN KHIRGANI

Man is a book. In him everything is written, but the darkness does not allow one to read this science inside himself.

RUMI

My station is devoteeship, my awareness Divinity, and my attributes Lordly. God's knowledge has filled that which is latent and apparent about me, and the earth and ocean of me are filled with His light.

ABU MADYAN

Man is born so that he may not be born again, and he dies so that he may not die again.

SATHYA SAI BABA

My journey was entirely within myself, and I saw that I was nothing but servanthood, without a trace of lordship.

IBN ARABI

Make a habit of being chivalrous and of telling the truth. Make a habit of good thoughts.

FIRDAWSI

Man thinks many things. He thinks he is One. Until he becomes One, he cannot have a fair idea of what he is at all.

SAMASI

Music is readily known. First the music rises, like a flock of birds; then this is followed by purification, clarification, continuation, and thus conclusion.

CONFUCIUS

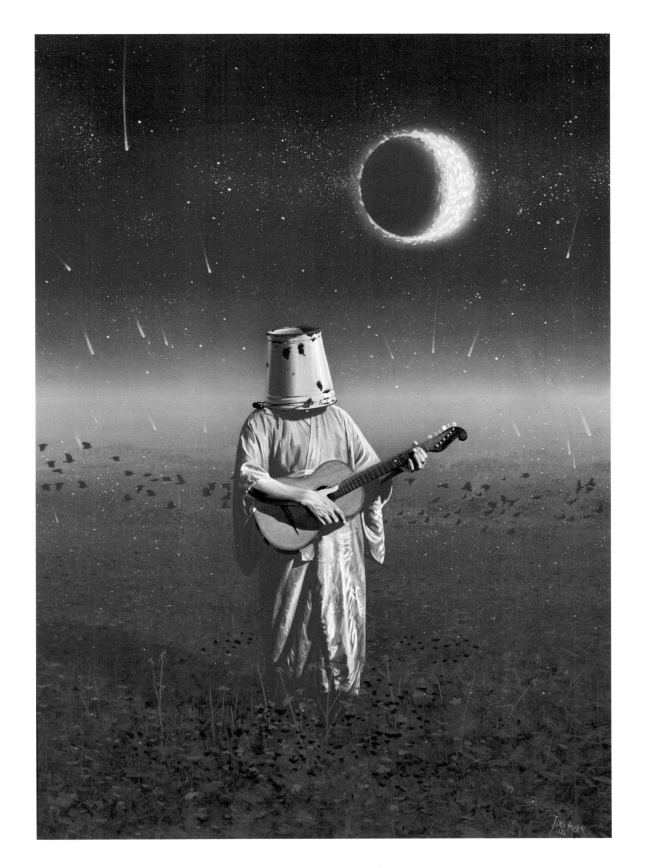

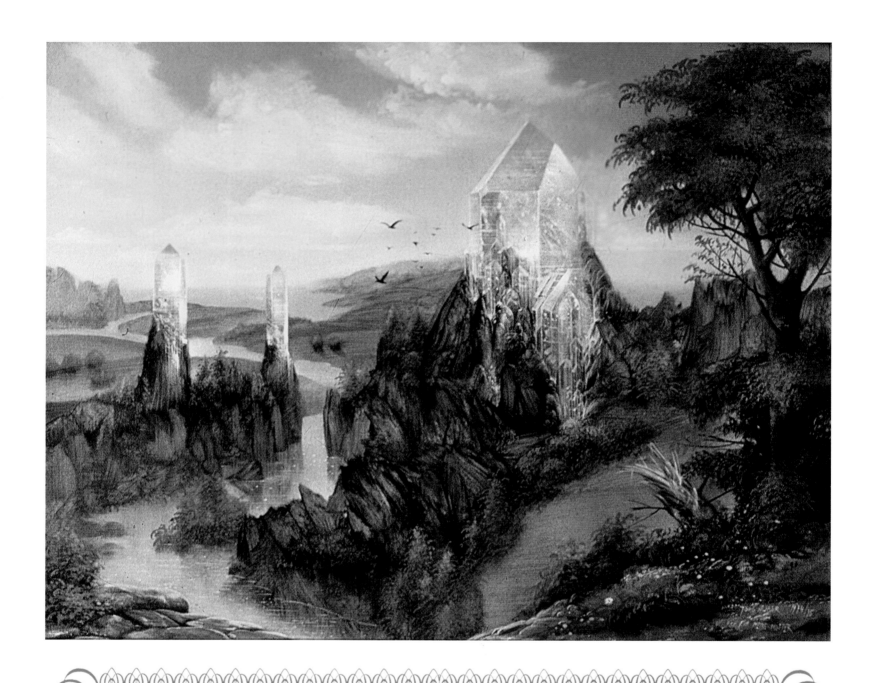

When a tree is full of green leaves, branches and fruits, you are attracted by it. When it becomes dry, you destroy it because there is no life in it. A person without love is akin to a dead tree.

SATHYA SAI BABA

Many a man who sees, does not see the Word, and many a man who hears, does not hear it.

RIG VEDA

May all sentient beings gain Love's splendour that dispels even the shadows of evil, through coming to know the Buddha of Love, and may all move forward, towards illumination.

GYALWA GENDUN DRUB

Man is of soul and body, formed for deeds of high resolve, on fancy's boldest wing to soar unwearied, fearlessly to turn the keenest pangs to peacefulness, and taste the joys which mingled sense and spirit yield.

PERCY BYSSHE SHELLEY

Many people know the surface of this ocean, but they ignore its depth.

FARID AD-DIN ATTAR

Man is not travelling from error to truth, but from truth to truth, from lower to higher truth.

SWAMI VIVEKANANDA

Man is what he loves. If he loves a stone, he is a stone. If he loves a man, he is a man. If he loves God … I dare not say more, for if I said that he would then be God, you might stone me!

ST AUGUSTINE

Mysterious even in open day
Nature retains her veil, despite our clamours;
That which she does not willingly display
Cannot be wrenched from her with levers, screws and hammers.

GOETHE

Man in the New Age will acquire celestial traits. He'll carry on his brow the mark of sacred grace.

FIRAQ GORAKHPURI

Man does not live by breath alone, but by Him in who is the power of breath.

KATHOPANISHAD

Make this world into a bridge over which you cross but on which you do not build.

HASAN-AL-BASRI

Make your best endeavour to worship at the temple of the heart.

ANSARI

Men of heart comprehend mysteries by instruments of music. Be a man of heart then and hear the words of the Organ.

FAYD-I KASHANI

Never plunge into the river of lust; you will not reach the shores. It is a river of no coasts where typhoons rage.

DWIJA KAILASHCHANDRA

New stars are appearing in the sky above; stars whose rolling waves of light have not been seen by the eyes of Man; stars just risen out of the dark dungeon of time; stars whose light is not hostage to day and night; stars whose radiance is both old and new, and partakes of the splendour of the star of your destiny too.

MUHAMMAD IQBAL

No bird soars too high if he soars with his own wings.

WILLIAM BLAKE

None can understand the sounds of a drum without understanding both drum and drummer.

BRIHADARANYAKA UPANISHAD

No obedient person should be self satisfied, and no disobedient person should lose hope.

AHMAD SAM'ANI

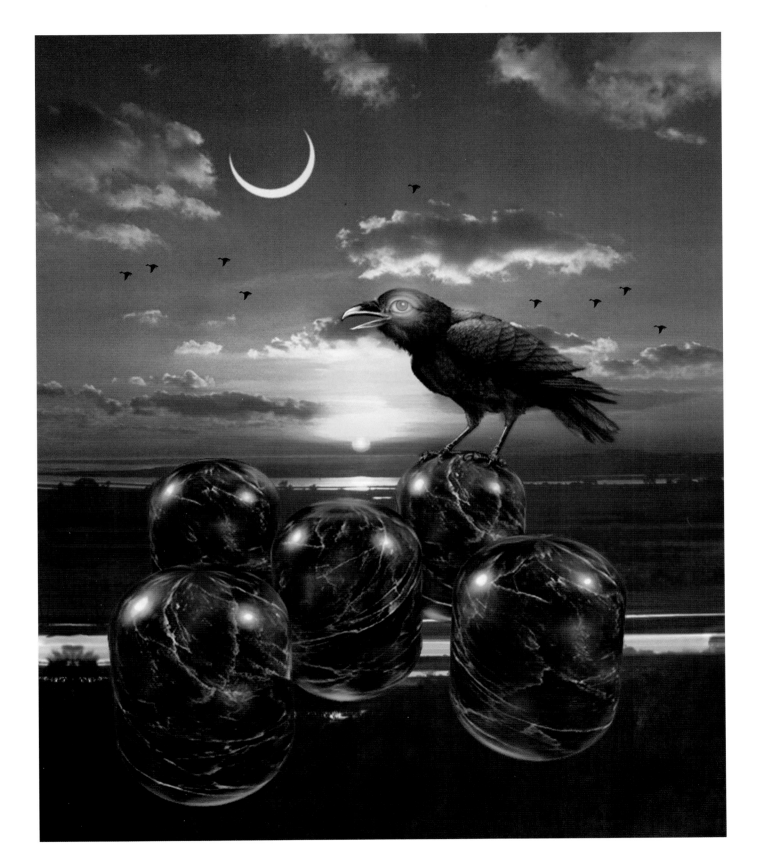

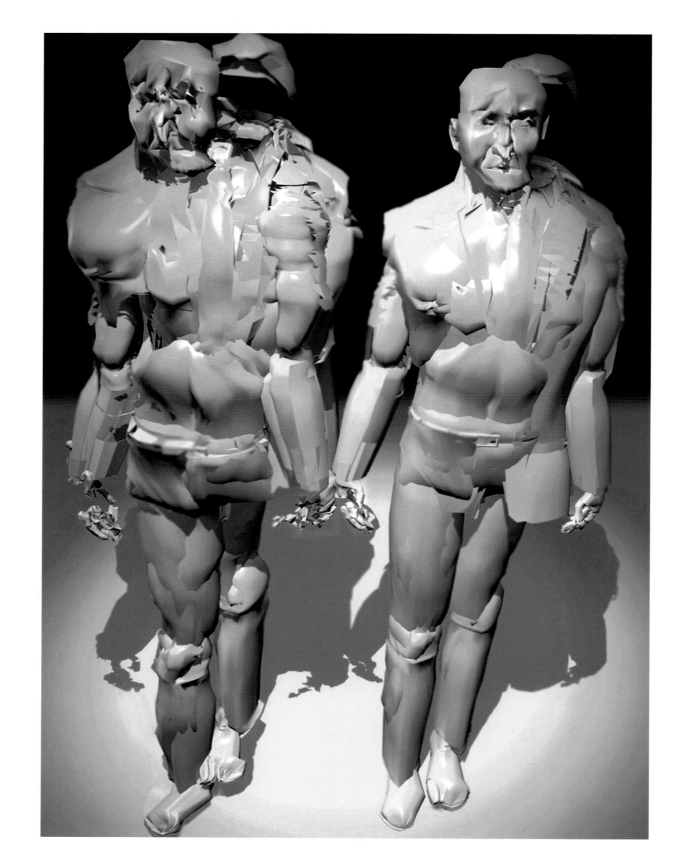

Nothing explains a thing except something that is subtler, and there is nothing subtler than love, so what can explain it?

SUMNUN AL-MUHIBB

Neither My Heaven nor My Earth can contain Me, yet the heart of My truly believing servant contains Me.

PROPHET MOHAMMED

No matter where you go, always do your duty as you see it, and know that I will be there inside you, guiding you every step of the Way. You are my own, dearer than dear to me. I will protect you as the eyelids protect the eyes. I will never leave you and you can never leave me.

SATHYA SAI BABA

Nothing begins and nothing ends that is not paid with a moan; for we are born in others' pain, and perish in our own.

FRANCIS THOMPSON

No easy task is it to discover the unclouded glory of the Spirit that lies behind the veil.

AL-GHAZALI

No man is free who cannot command himself.

PYTHAGORAS

Nothing is better for Man than to be without aught, having no asceticism, no theory, no practice. When he is without all, he is with all.

ABU YAZID BASTAMI

No man shall attain the shores of the ocean of true understanding except he be detached from all that is in heaven and on earth.

BAHA'U'LLAH

Never complain, never explain. Love work for work's sake and not for its gain.

G I GURDJIEFF

Neither the scriptures nor the sacred texts, can ever rend asunder the curtain of the mind. In front of the curtain is man, and behind it is God; cause on one side, and consequence on the other.

SATHYA SAI BABA

Other worlds exist beyond the stars. More tests of love are still to come.

MUHAMMAD IQBAL

On the other shore of the ocean of one's own self, quivers a drop of fluid, as the origin of all. But who can cross the seas to reach it? The root of all is based in you. Explore the base to reach the essence.

HAUDE GOSAIN

One who fattens himself by killing and devouring other lives, has forgotten to kill the animals which, day by day, are killing him and eating him from within.

SHEIKH M R BAWA MUHAIYADDEEN

Our pure hearts roam across the world. We get bewildered by all the idols we see, yet what we're trying to understand in everything, is what we already are.

RUMI

One religious teacher is worth ten secular teachers, one father is worth a hundred religious teachers, but one mother is worth a thousand fathers.

VENERABLE NARADA MAHA THERA

Once I had been a slave; lust was my master. Lust then became my slave and I was free. Leaving the haunts of men, I sought Your presence. Lonely, I found in You my company.

AL-GHAZZALI

Our true self is the ultimate reality of the universe, and if we know the true self, we not only unite with the good of humankind in general, but also fuse with the essence of the universe, and unite with the will of God.

NISHIDA KITARO

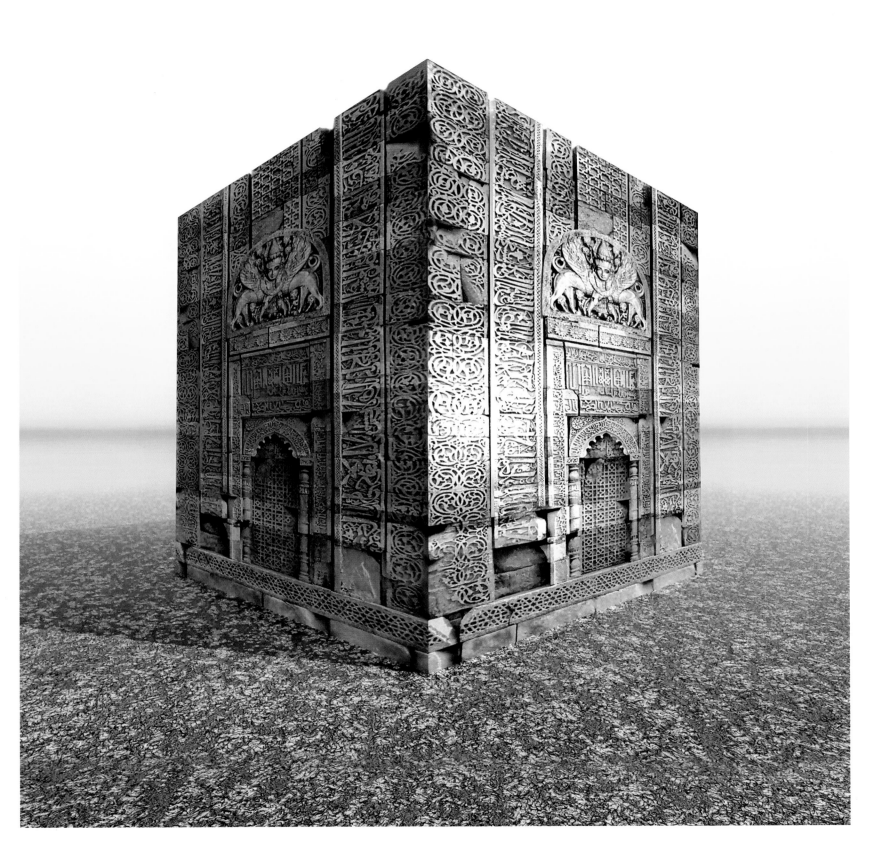

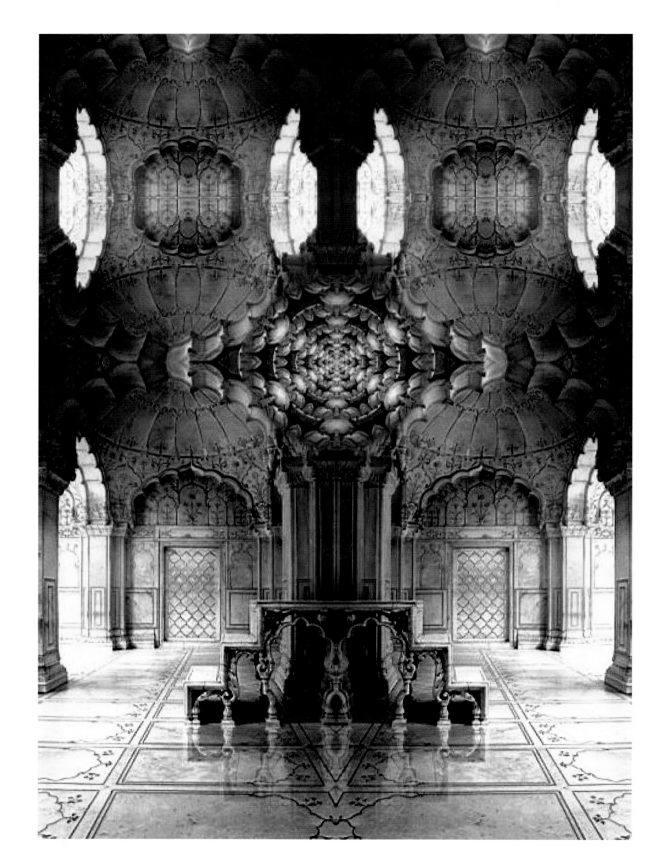

Oh God, give me a light in my heart, a light in my grave, a light in my ear, a light in my eye, a light in my hair, a light in my skin, a light in my flesh, a light in my blood, a light in my bone, a light before me, a light behind me, a light on my right side, a light on my left side, a light above me, a light below me. Oh God, give me more light, give me light.

ABU HAMID AL-GHAZALI

Only those return to Eternity who on earth seek out Eternity.

KAHLIL GIBRAN

Ordinary human love is capable of raising man to the experience of real love.

HAKIM JAMI

One who hears, does
One who does, sees
And one who sees, enjoys
At this place, if God is kind, what good fortune comes.

SHAH MIRANJI SHAMS AL-USHSHAQ

Our deeds still travel with us from afar, and what we have been, makes us what we are.

GEORGE ELIOT

Only he knows the bitterness of love who has deeply felt its pangs. When you are in trouble no one comes near you. When fortune smiles, all come to share the joy.

MIRABAI

Love and imagination are magicians who create an image of the Beloved in your mind with which you share your secret intimate moments.

RUMI

Love is the undercurrent of human life. Man will be able to manifest his innate divinity only when he develops love within.

SATHYA SAI BABA

Friends become enemies because we see them as separate from us. But in reality, we are quarrelling with ourselves.

RUMI

Our deepest life is when we are alone. We think most truly, love best, when isolated from the outer world in that mystic abyss we call the Soul.

GEORGE WILLIAM RUSSELL

Once, inconceivable, you walked, majestic brothers and sisters of constellations, among the temples. Even today, holiness like the distant fragrance of gods, drifts round your brows, dignity round your knees. Your beauty breathes calmly; your home is eternity.

HERMANN HESSE

Observe this simple counsel of perfection: forsake all and you shall find all. Renounce desire and you shall find peace. Give this due thought and when you have put it into practice, you will understand all things.

THOMAS A KEMPIS

One love it is that pervades the whole world. Few there are who know it fully. They are blind who hope to see it by the light of reason, that reason which is the cause of separation. The house of reason is very far away.

KABIR

Our life's repose is in the Infinite; It cannot end, its end is Life Supreme. Death is a passage, not the goal of our walk.

AUROBINDO

Oh Lord, if I worship You for the fear of Hell, burn me in it, and if I worship You in the hope of Paradise, make it unlawful for me. But if I worship You for Your sake, then do not deprive me of Your beauty.

RABIA AL-ADAWIYA

Oh ignorant One: when we die it will be proven to us: a dream was what we have seen and that what we have heard was a tale.

MIR DARD

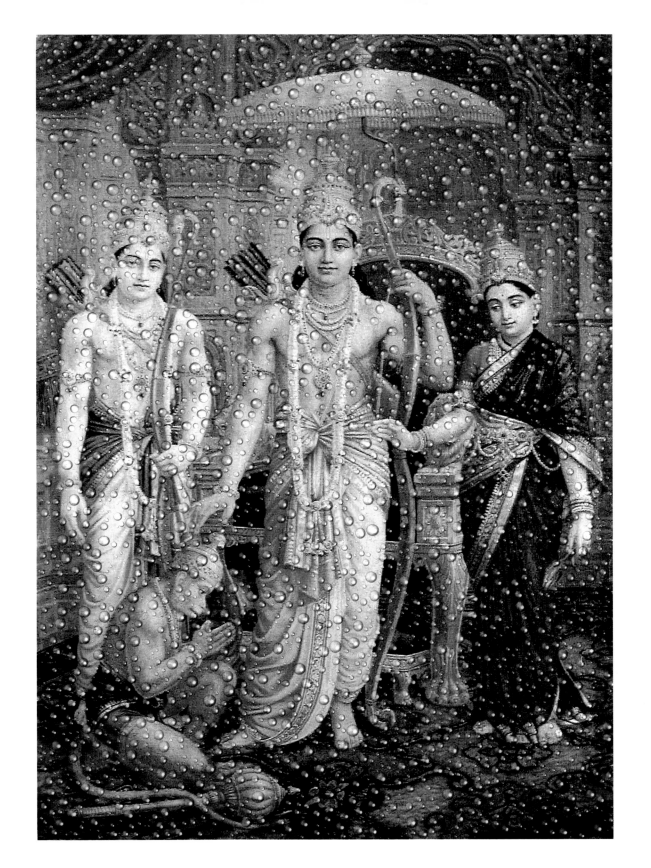

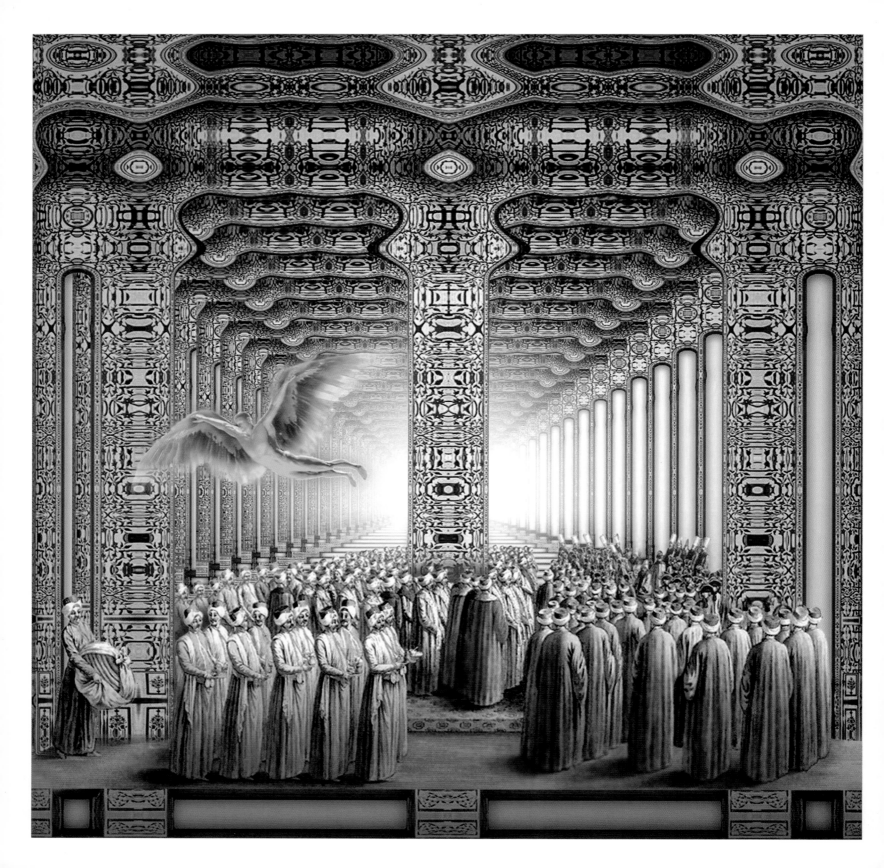

Of what are heroes, prophets, men, but pipes through which the breath of Pan doth blow a momentary music.

RALPH WALDO EMERSON

Pearls were scattered on the Path but those who came by were blind. Without the Light of the Lord, the world steps over them.

KABIR

Partial reason gives reason a bad name. Base desire holds us back from our desires.

RUMI

Pain born of Divine Love is preferable to pleasure experienced by the soul estranged from the Beloved.

'AYN AL-QUDAT

Pleasure is an interval between two pains.

SATHYA SAI BABA

People who do not think far enough ahead, inevitably have worries near at hand.

CONFUCIUS

Patience is the key to joy.

RUMI

Pear seeds grow into pear trees, nut seeds grow into nut trees, and God seeds grow into God.

MEISTER ECKHART

Perfect love proceeds from the lover who hopes naught for himself. What is there to desire in that which has a price? Certainly the Giver is better for you than the gift.

ABU AL-QASIM BISHR YASIN

Prayer is the key of the morning and the bolt of the evening.

MAHATMA GANDHI

Physical love is selfish. It is fleeting like lightening. It is ever changing. It ends in quarrels and divorce. Divine love is everlasting.

SWAMI SIVANANDA

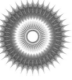

Rise above time and space, pass by the world, and be to yourself your own world.

SHABISTARI

Remember that pain has this most excellent quality; if prolonged it cannot be severe, and if severe, it cannot be prolonged.

SENECA

Reality is manifest in every created being and in every concept, while He is hidden from all understanding, except for the One who holds that the Cosmos is His form and His identity.

IBN ARABI

Real vision is the seeing of one's own self, not of something that is other than self.

GAUTH ALI SHAH

Since Love has filled my heart, my neighbour has not been able to sleep because of my sighs. Now my complaints have diminished, my love has grown. When fire is ignited by wind, it creates no smoke.

RUMI

Separation from Thee is dearer to me than union with others.

MUHAMMAD IQBAL

Some travel the seven cities of Love. Some reach only a single street.

TRADITION

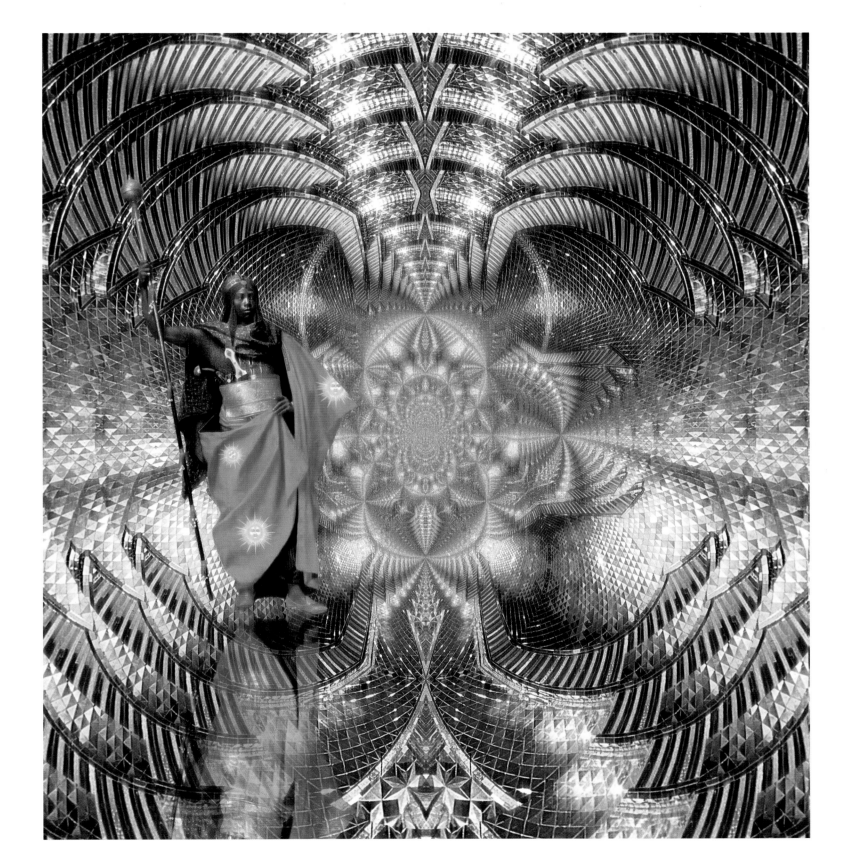

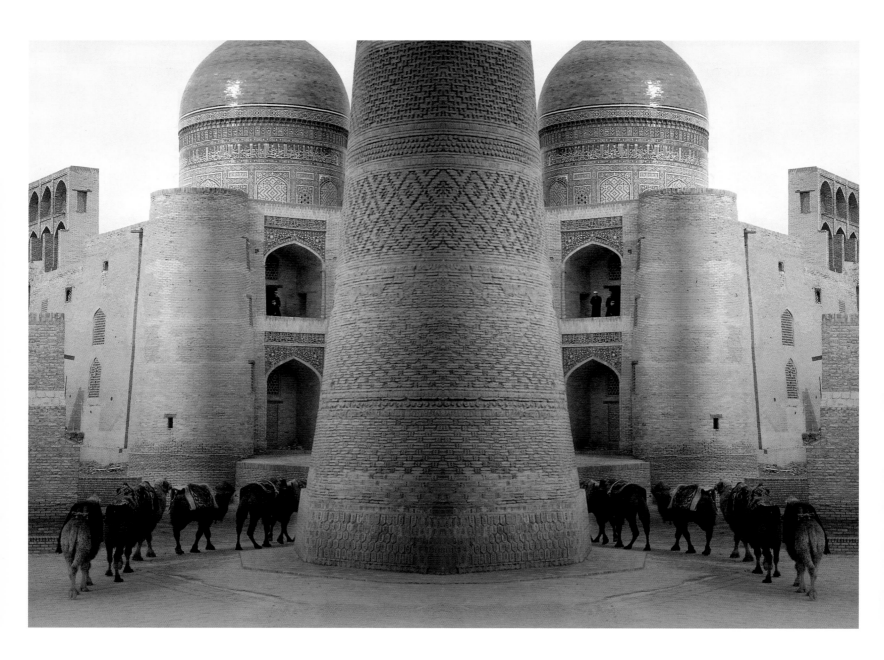

Speak to everyone in accordance with his degree of understanding.

PROPHET MOHAMMED

Service to people is the whole of worship. The worship of God is not done by rosary beads, robes of piety or prayer carpets.

SA'DI

Stop speaking and let your Spirit speak through you.

RUMI

Sadness is but a wall between two gardens.

KAHLIL GIBRAN

See God in everyone. It is deception to teach by individual differences.

NEEM KAROLI BABA

See the One, know the One, say the One, seek the One, and whatever you see, regard as Him.

SAIYID MUHAMMAD GHAUS OF GWALIOR

Study without thinking, and you are blind; think without studying, and you are in danger.

CONFUCIUS

Speak in whispers, ye who assist at a death bed and find yourselves in the solemn presence of Death. Especially have you to keep quiet just after death has laid her clammy hand upon the body. Speak in whispers, I say, lest you disturb the quiet ripple of thought, and hinder the busy work of the Past casting on its reflection upon the veil of the Future.

MASTER KOOT HUMI

Strange is the Path when you offer your love. Your body is crushed at the first step. If you want to offer love, be prepared to cut off your head and sit on it!

MIRABAI

Serve the Designer of all this Dreamland rather than the Dream itself.

SATHYA SAI BABA

Science without religion is blind; and religion without science is lame.

ALBERT EINSTEIN

Show me things as they really are. Man is a mighty volume. Within him all things are written, but veils and darknesses do not allow him to read that Knowledge within himself.

RUMI

Strange is the heart which listens to the sorrows of men and is not touched by it.

SHAIKH NIZAMU'D-DIN AULIYA

The one who knows is not the one who borrows his knowledge from a book, and then becomes ignorant when he forgets what he has learned. He is the one who receives his knowledge from his Lord, directly, whenever he wants, without study or teaching.

ABU YAZID BISTAMI

The language of the spiritual state is more eloquent than my language, and my silence is the interpreter of my question.

AL-HUJWIRI

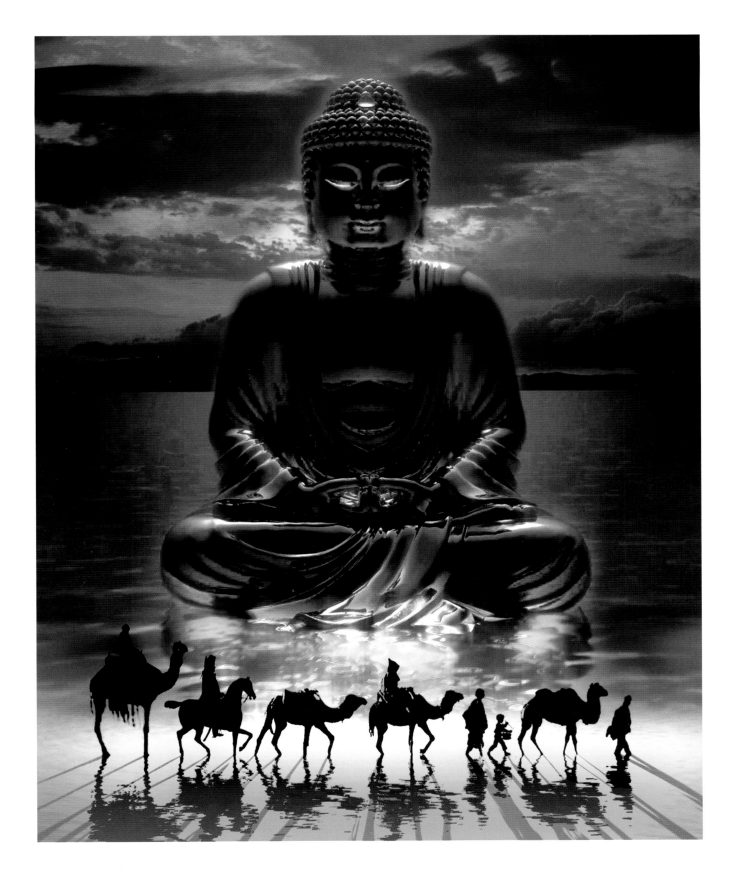

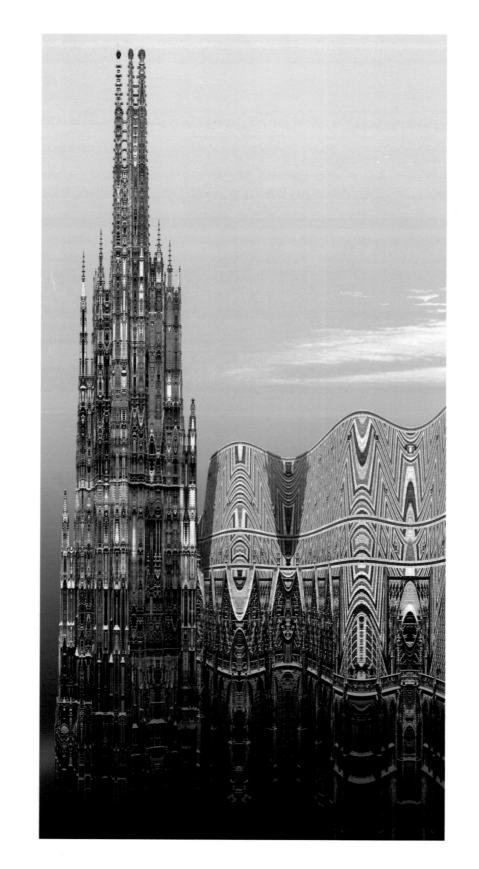

The Master of the Universe belongs to no one, but you must know Him. As you explore your mind looking for Him, feelings override thoughts.

CHANDIDAS GOSAIN

To find nectar, stir the cauldron on the fire, and unite the act of loving with the feeling for love.

ERFAN SHAH

The essence of beauty in the mirror of love stares at His face; the formless within the visible form.

GURUCHAND

The wisdom of the East and the West has taught me something that will prove elixir to slaves: whether it is religion or philosophy, poverty or kingship, all take firm beliefs as their base. The words that a nation speaks are dead and its actions are futile if its heart is bereft of firm beliefs.

MUHAMMAD IQBAL

The breath that does not repeat the name of Love, is a wasted breath.

KABIR

The concern of the ascetic is not to eat, while the concern of the agnostic is what to eat.

AL-GHAZALI

There lies a green field between the scholar and the poet. Should the scholar cross it, he becomes a wise man. Should the poet cross it, he becomes a prophet.

KAHLIL GIBRAN

The eye is the lamp of the body. If your eye is sound, your whole body will be full of light.

JESUS

The gates of the world of the miraculous may be opened only to him who seeks.

P D OUSPENSKY

To a fearless heart, a lion is a sheep; to a timid heart, a deer is a tiger. If you have no fear, the ocean is a desert; if you are fearful, there is a crocodile in every wave.

MUHAMMAD IQBAL

The principle of Divine Love is to invoke God's name constantly, and under all circumstances, to strive with all the might of one's soul to know Him, and never to have anything in one's sight but Him.

ABU MADYAN

There is the path of joy and the path of pleasure. The two paths lie in front of one. Pondering on them, the wise one chooses the path of joy; the fool takes the path of pleasure.

KATHA UPANISHAD

The song of the voice is sweet, but the song of the heart is the pure voice of heaven.

KAHLIL GIBRAN

The Beloved's water washes all illness away. The Beloved's rose garden of union has no thorns. I've heard it said there's a window that opens between heart and heart, But if there are no walls, there's no need even for a window.

RUMI

The Teacher is he who hears you and then unveils you to yourself.

IBN ARABI

The world is for me like a tree, under which a traveller takes shade for a while.

PROPHET MOHAMMED

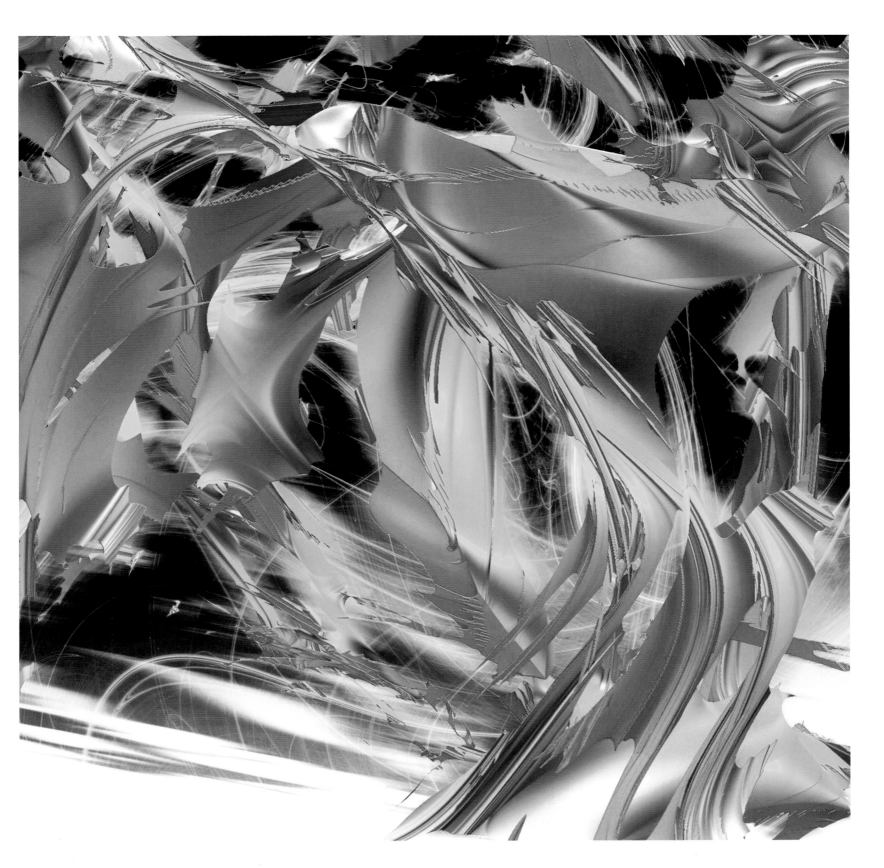

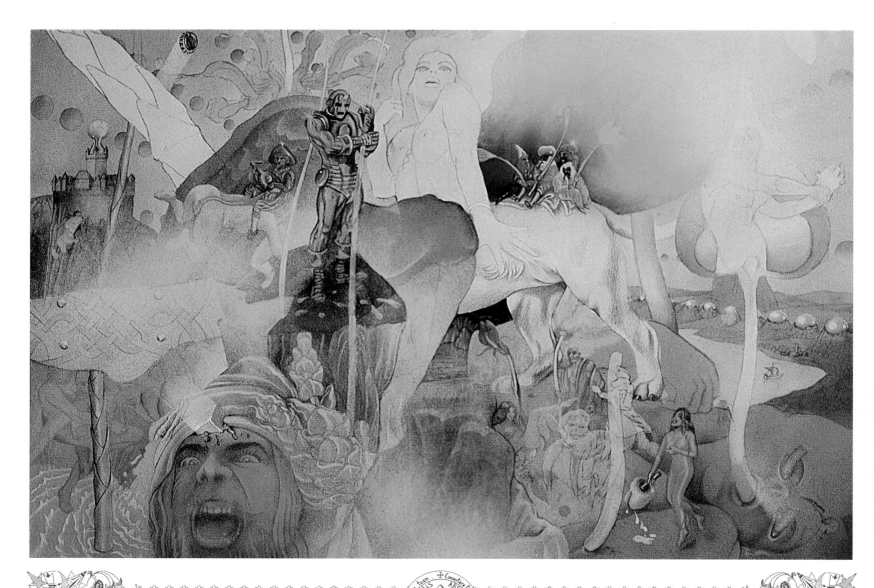

When you see good and evil coming from Him, then everything you perceive will be good. As long as you are possessed by egotism, you are a foe to God. As long as you perceive God's action from your own finite perspective, good will appear to you as evil. None who is conceited can see the good in this world: here ends all debate on this issue.

SHABISTARI

To see a world in a grain of sand
And heaven in a wild flower
Hold infinity in the palm of your hand
And eternity in an hour.

WILLIAM BLAKE

That which is at the centre of the space in my heart, it is the very same that is in the sun, which is in the earth, in the heart of every man, at the heart of every being.

CHANDOGYA UPANISHAD

Ten thousand flowers in spring, the moon in autumn, a cool breeze in summer, snow in winter.
If your mind isn't clouded by unnecessary things, this is the best season of your life.

WU-MEN

There are hundreds of ways to kneel and kiss the ground.

TRADITION

The soul of one who loves God always swims in joy, always keeps holiday and is always in the mind for singing.

ST JOHN OF THE CROSS

There is an indefinable mysterious power that pervades everything; I feel it though I cannot see it.

MAHATMA GANDHI

Three short phrases tell the story of my life. I was raw, I got cooked, I burned.

RUMI

The ultimate destiny of the entire world is to reach the dwelling place of pure pardon and superlative compassion.

IBN ARABI

There is no greater sin than desire, no greater curse than discomfort, no greater misfortune than wanting something for oneself. He who knows that enough is enough will always have enough.

LAO-TZU

The essence of right conduct is not to injure anyone. One should know only this, that non-injury is religion.

NALADIYAR

This road is full of footprints. Companions have come before. They are your ladder; use them.

RUMI

The way to find Friendship is to toss this world and the hereafter into the sea. The sign of the realisation of Friendship is not to care for anything that is not God. The beginning of Friendship is to have an imprint; the end is having a lamp.

ANSARI OF HERAT

The wish to get free of suffering is the legitimate role of every human being. Thus it is entirely appropriate that we seek the causes of our unhappiness and do whatever we can to alleviate our problems. But as long as we view suffering as an unnatural state, we will never uproot the causes of suffering and begin to live a happier life.

DALAI LAMA

The Bestower of Light to all creation is One, though a thousand mirrors there may be.

DR JAVAD NURBAKHSH

The human voice can never reach the distance that is covered by the still small voice of conscience.

MAHATMA GANDHI

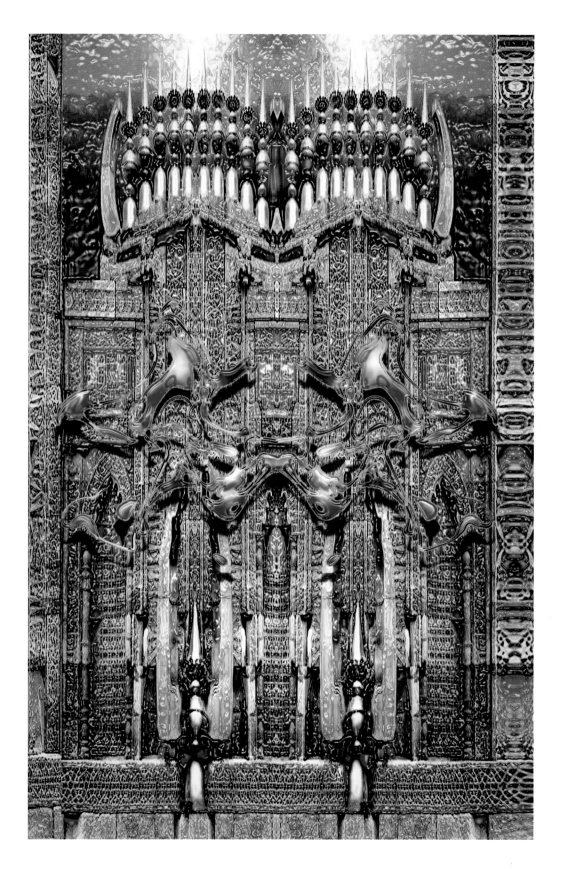

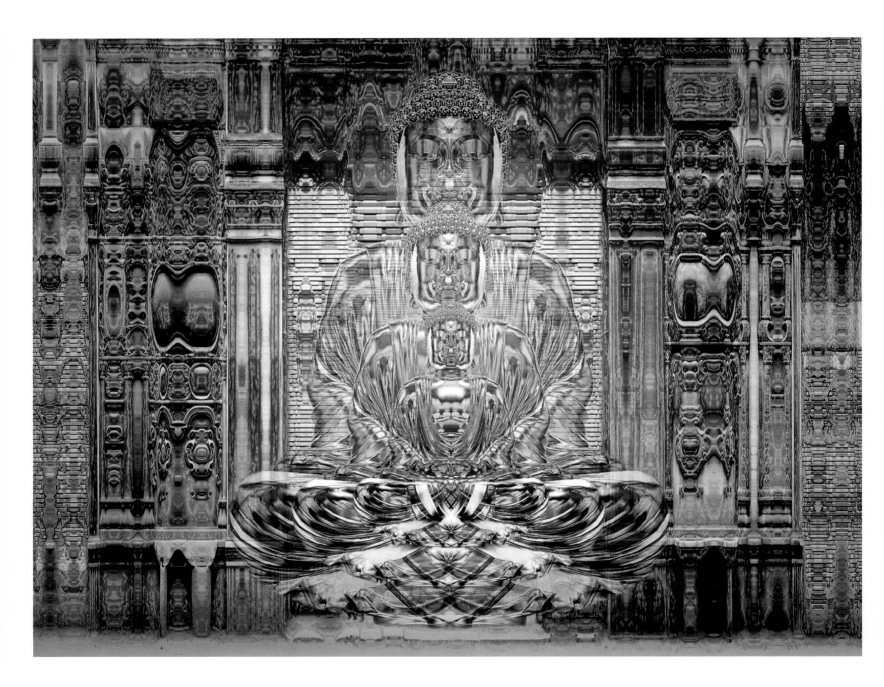

There first must be a True Man before there can be true knowledge.

CHUANG TZU

That which is boundless in you, abides in the mansion of the sky, whose door is the morning mist, and whose windows are the songs.

KAHLIL GIBRAN

The more taboos and prohibitions there are in the world, the poorer the people will be. The more sharp weapons the people have, the more troubled the State will be.

LAO-TZU

The mind is full of waves of love that permeate the whole body. Hark the sweet music of love that swells and sweetens the heart.

KABIR

To achieve the Way is not difficult; just reject discrimination. If you cast aside the mind that discriminates, then at once you gain awakening. To abandon the discriminating mind means to break free from the Self.

DOGEN KIGEN

The foundation of the created world is love. All motion, activity, and light, throughout the entire universe as we know it, derive from the rays of light, and true perfection must be sought in and through love.

DR JAVAD NURBAKHSH

The essence of all religions is One. Only the approaches are different.

MAHATMA GANDHI

The place of Love is the heart, and the heart is pure gold, the pearl of the breast's ocean, the ruby of the innermost mystery's mine. The Divine Majesty polished it by gazing upon it, making it bright and pure.

AHMAD SAM'ANI

The body is a compound of perishable organs. It is subject to decay. We should attend to its needs without being attached to it, or loving it.

LORD BUDDHA

 The world is sweet for those who find it like Eden.

BAHA WALAD

His Lord revealed to him the Mountain and made it in a moment dissolve into dust.

QUR'AN

 The whole world is the garment of the Lord.

ISHOPANISHAD

Those tender words we said to one another are stored in the secret heart of Heaven. One day, like the rain, they will fall and spread and their mystery will grow green over the world.

RUMI

The tongue is the key to the heart. The more the tongue moves in uttering the remembrance of God, the more the heart opens up and the more that precious things appear within it.

BAHA WALAD

If knowledge does not liberate the Self from the Self, then ignorance is better than knowledge.

SANA'I

The rose is precious; enjoy her company now. For into the garden she came this way, and soon she will go that way.

HAFIZ OF SHIRAZ

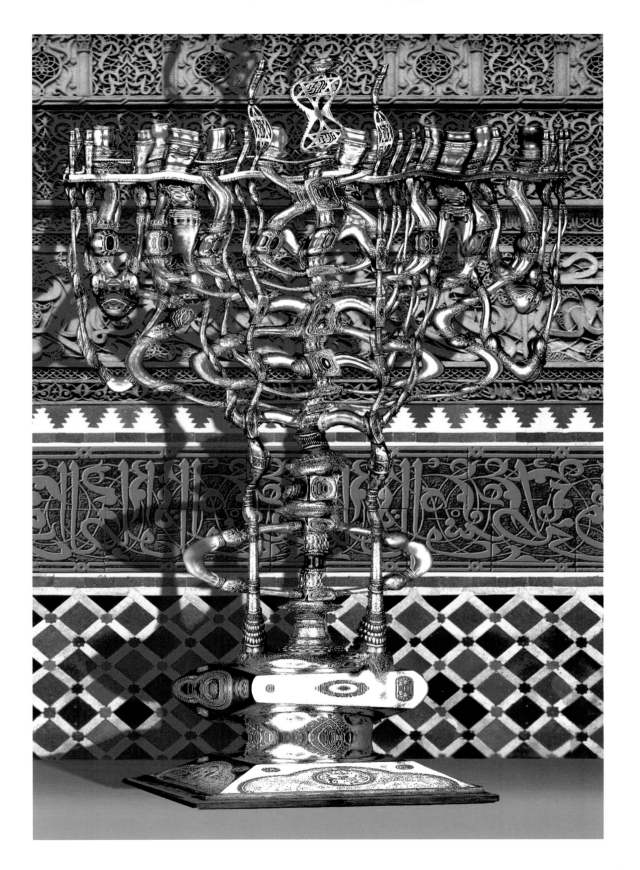

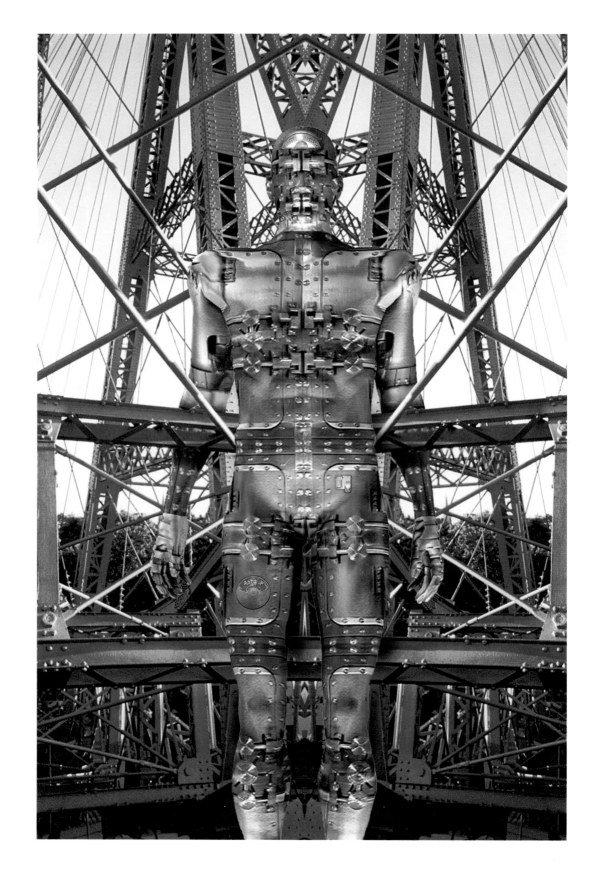

The royal road leading your soul to God is nothing but the cleansing of the heart's mirror.

SANA'I

Trees are poems that the earth writes upon the sky. We fell them down and turn them into paper so that we may record our emptiness.

KAHLIL GIBRAN

The stars of Heaven come out to look upon us. We shall show the moon herself to them, You and I.

RUMI

There is no disease more fatal than greed
There is no foe more dangerous than anger
There is no grief more miserable than poverty
There is no joy greater than wisdom.

SATHYA SAI BABA

The water-drop's bliss is to merge with the sea. Pain, crossing its limits, becomes its' own remedy.

GHALIB

Thou art light Divine, Thou art light of Knowledge, Thou art the sea, Thou art the waves, the inner ruler of all beings.

SWAMI SIVANANDA

The truth is like a light in the distance. You want to reach the light but by the time you get there, you're completely burned away.

DR JAVAD NURBAKHSH

There is a higher court than courts of justice and that is the court of conscience. It supersedes all other courts.

MAHATMA GANDHI

To be poor without bitterness is easy; to be rich without arrogance is hard.

CONFUCIUS

The charmer of hearts has gone, having caught me in the noose of love. On the bough of a mango tree, a cuckoo is pouring forth her plaintive song. The world just laughs but for me it is death. I tramp the forests in desolation, at the absence of the Beloved.

MIRABAI

The secret arrow of love has pierced my heart. I cannot suppress my tears, however much I try. They flow like streams and drench my clothes. I feel joy in Thy remembrance, happiness in singing Thy praise. I feel solace in my tears, pleasure in Thy name.

SWAMI SIVANANDA

The human body is always finite; it is the spirit that is boundless. Before he begins to pray, a person should cast aside that which limits him, and enter the endless world of Nothing.

SHEMUAH TOVAH

The Good which is above all light, is called a spiritual Light because it is an originating beam and an overflowing radiance, illuminating with its fullness, every mind above the world, around it or within it, and renewing all their spiritual powers, embracing them all by its transcendent elevation.

DIONYSIUS

The love that keeps this Heaven ever the same, greets all who enter with such salutation and thus prepares the candle for His flame.

DANTE ALIGHIERI

Thousands of people may live in the world but we cannot call it a Fellowship until they know each other and have sympathy for each other.

MAHAPARINIRVANA SUTRA

This Spiritual Love acts not, nor can exist without imagination, which in truth is but another name for absolute power and clearest insight, amplitude of mind and reason, in her most exalted mood.

WILLIAM WORDSWORTH

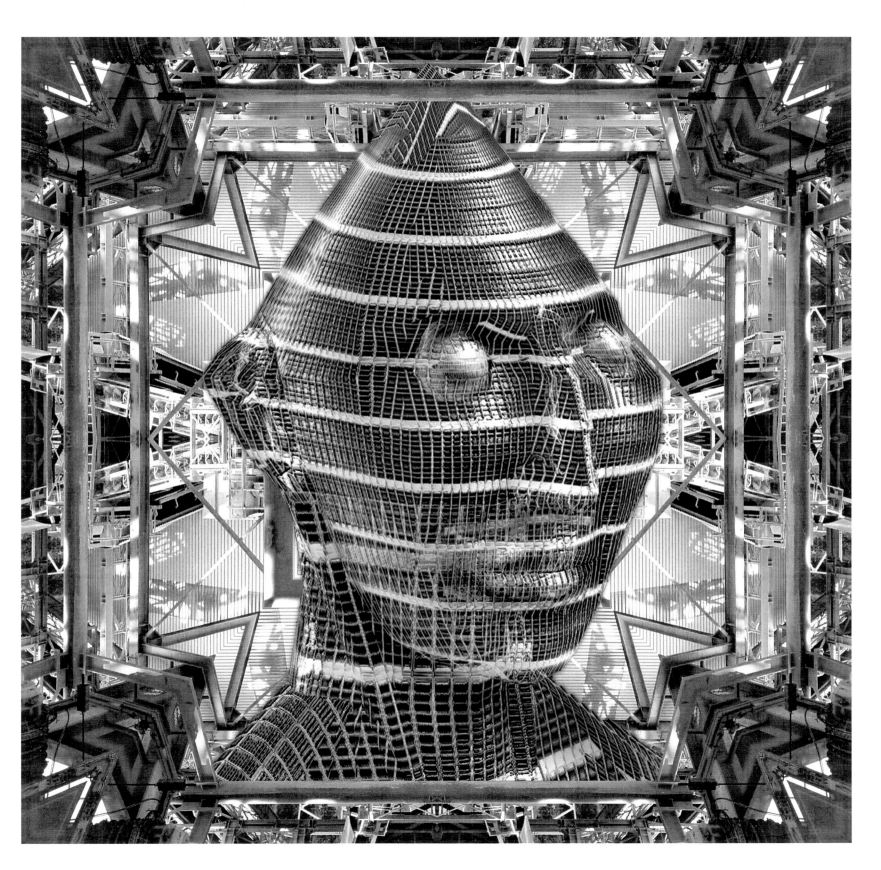

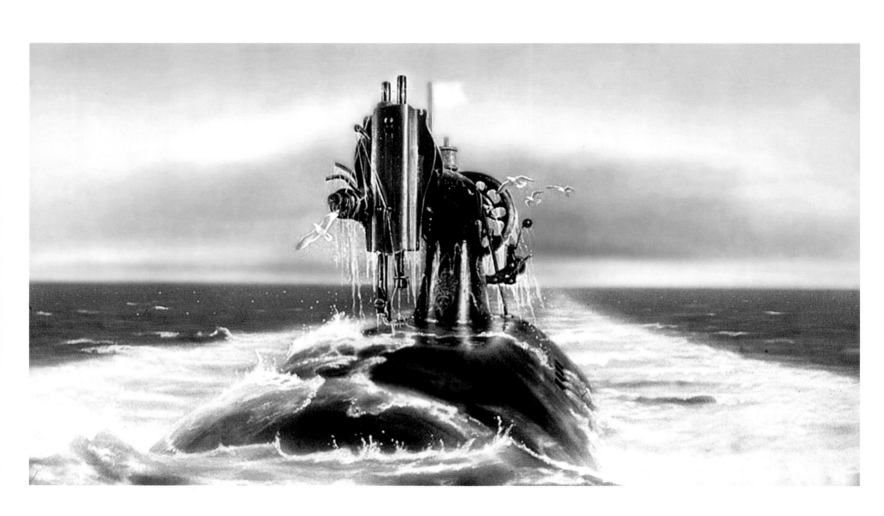

The essentials of all religions are the same. Serve, love, give, purify, realise, be good, do good, be kind, be compassionate. Enquire "Who am I?". Know the self and be free. Love all, serve all, serve the Lord in all. Speak the truth, be pure, be humble, concentrate, meditate, attain self realisation. These are the essentials of all religions.

SWAMI SIVANANDA

The mind that is freed from passions, worldly ties and contention, and from dependence, is liberated from the bonds of ignorance and error like a bird let loose from its cage. When the disturbances of doubt are stilled and the wanderings of curiosity are done, then the full moon of eternal fullness sheds its lustre over the mind.

YOGA VASISHTHA MAHARAMAYANA

I would love to kiss You and the price of this kissing is my life. Now my love is running towards my life shouting "What a bargain, let's buy it!"

RUMI

The soul walks not upon a line, neither does it grow like a reed. The soul unfolds itself like a lotus of countless petals.

KAHLIL GIBRAN

Those of you who would know yourselves in the spirit of truth, learn to live alone even amidst the great crowds which may sometimes surround you.

MASTER KOOT HUMI

Those who know do not speak; Those who speak do not know.

LAO-TZU

Those who see all creatures in themselves and themselves in all creatures, know no fear and no grief.

ISHA UPANISHAD

There is nothing that love cannot achieve in this world. It can even melt the hardest of rocks. When the principle of love in every human being is unified, it becomes Cosmic Love.

SATHYA SAI BABA

The pleasures of Paradise derive from hell; the taste of cake is felt by the sense of hunger; the effect of a healing balm depends upon the existence of a sore.

SHABISTARI

The speech of love soars beyond words and their meanings; love speaks through a different voice, in a different tongue.

DR JAVAD NURBAKHSH

This life races towards death like a river pouring over a cliff. No one is sure to be alive, even this evening, when the grinning sun drops behind the West.

LOSANG KALSANG GYATSO

The whole temporal world is a vast transparency through which the Eternal shines.

HENRY DRUMMOND

The silkworm gets encased in the cocoon spun by itself. Similarly, the worldly man gets entangled in the meshes of his own desires. But when the silkworm develops into a butterfly, it breaks open its nest and comes out to enjoy the light and air outside. Likewise, when a man in bondage cuts asunder attachment to illusions, he is able to behold God.

RAMAKRISHNA PARAMAHAMSA

There are three types of persons. Those who confess their own faults and mention the excellence of others, belong to the highest type. Those who highlight their own excellence and decry the faults of others, are worse. Those who parade their own faults as excellence and deride the excellence in others are the worst. Nowadays, the last type is most rampant.

SATHYA SAI BABA

There is no fire like lust
There is no master like hatred
There is no snake like folly
There is no torrent like greed.

THE DHAMMAPADA

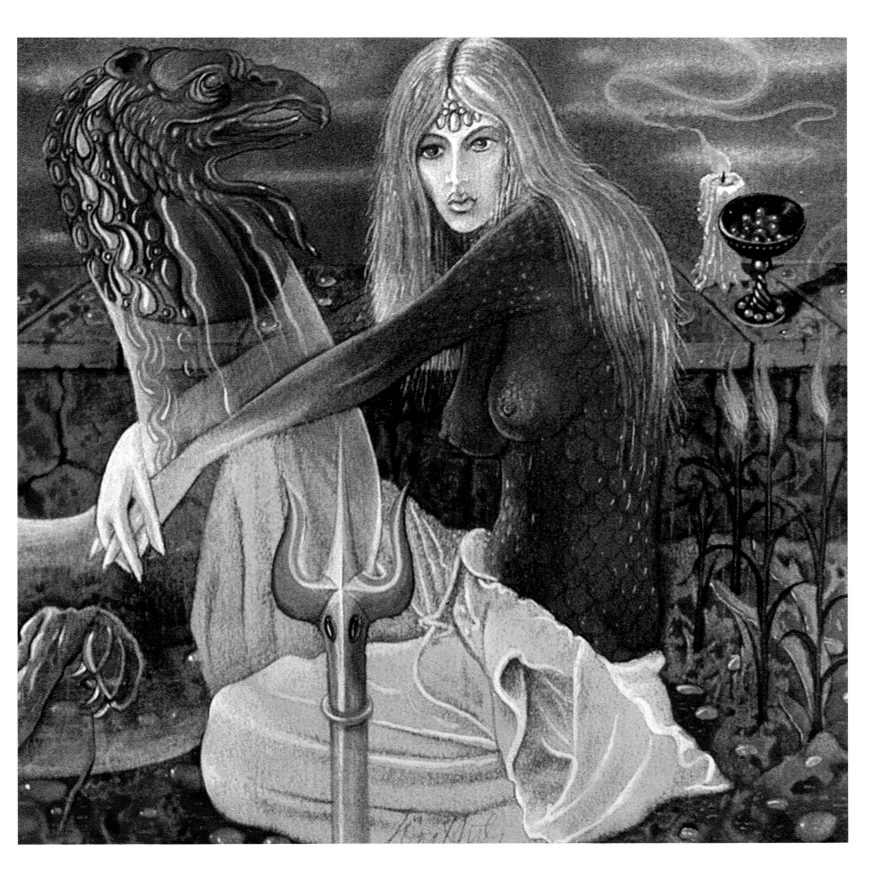

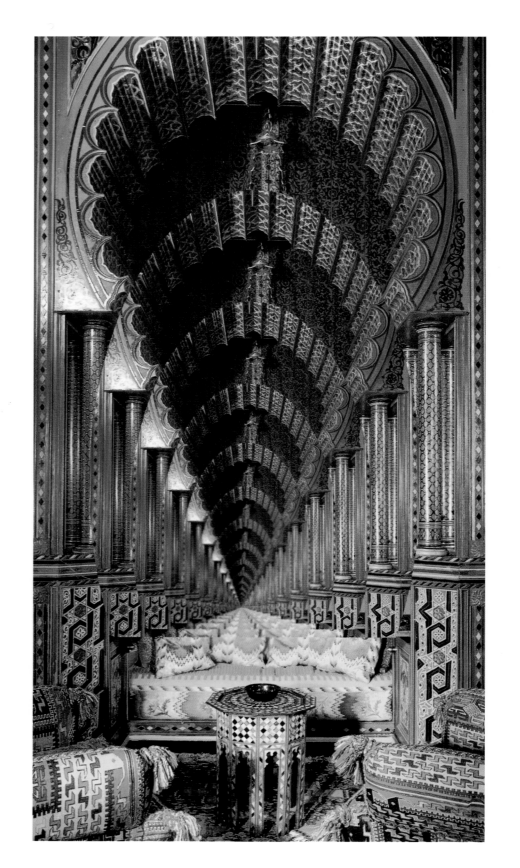

The mind is universal. Your mind, my mind, all these little minds, are fragments of that Universal Mind, little waves in the ocean; and on account of this continuity, we can convey our thoughts directly to one another.

SWAMI VIVEKANANDA

The road that leads to God's own mind
Is nothing more than of mankind.
If man holds man in high esteem,
He has revered his Maker's name.
Look in our hearts and He is there;
Our hearts are homes with Him to share.

NAIM OF FRASHER

The secret of happiness lies not in doing what you like, but in liking what you have to do. That is a great Truth.

SATHYA SAI BABA

The best school is life
The best teacher is experience
The best book is nature
The best temple is the heart
The best friend is God.

J P VASWANI

The pain of the mind is worse than the pain of the body.

SYRUS

The universe is a vast book; the characters of this book are all written, in principle, with the same ink and transcribed on the Eternal Table by the Divine Pen.

IBN ARABI

The world is a ring which Master's fingers hold and I, the gem, embossed with His ensign.

OMAR KHAYYAM

The whole of this world is a mosque.

PROPHET MOHAMMED

The only way of doing good to the world is to do good to yourself.

C G JUNG

The body is an enclosure in which the soul is incarcerated until the penalty is paid.

PLATO

The soul always abides on high. When the prescribed period arrives,
the soul spontaneously descends and enters into the body.

PLOTINUS

Talk less and paint more.

GOETHE

To study nature is to discover God.

SRI KRISHNA

The man and his body are different things. What, therefore, is the man? He who uses his body.

PLATO

The world is a mirror of His beauty and nature is a temple of His light.

T L VASWANI

The world is a caravan inn, where man can rest awhile during his pilgrim to his source, the Divine.

SATHYA SAI BABA

The shining of the Self illumines the entire world.

MUNDAKA UPANISHAD

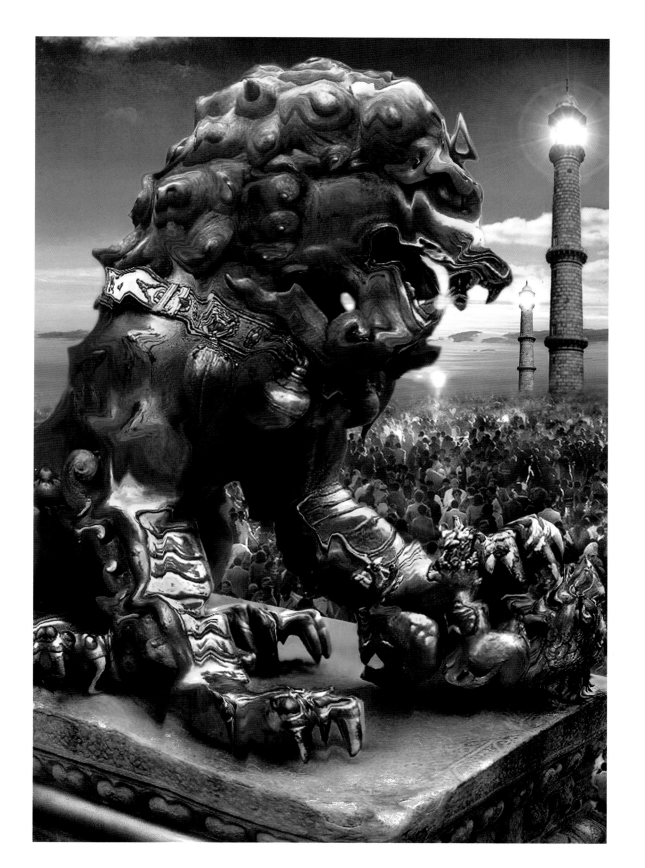

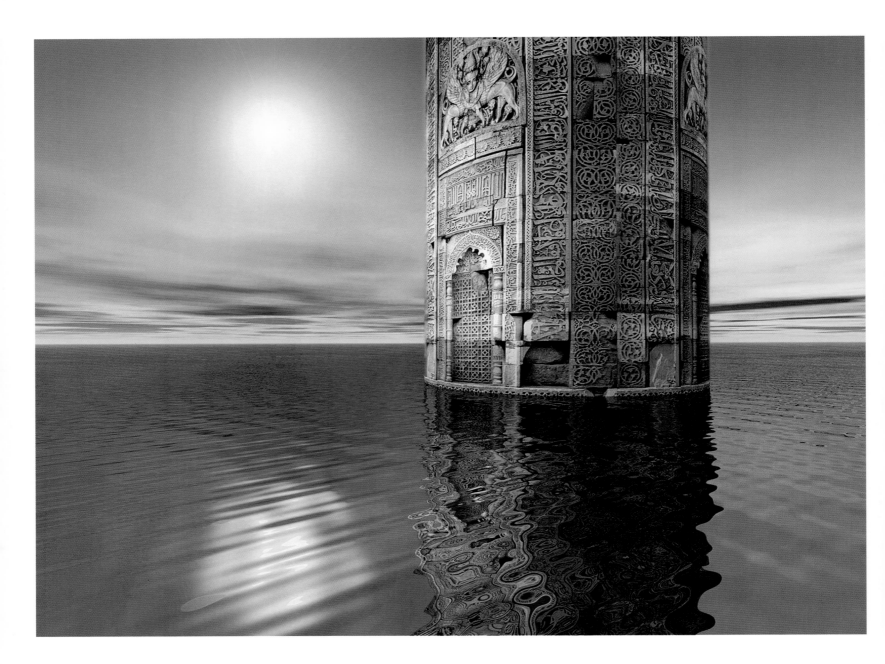

The soul that is attached to anything, however much good there may be in it, will not arrive at the liberty of Divine Union. For whether it is strong wire rope or a slender delicate thread that holds the bird, it matters not, if it really holds it fast. For until the cord be broken, it cannot fly. So the soul, held by the bonds of human affections, however slight they may be, cannot, while they last, make its way to God.

ST JOHN OF THE CROSS

There will be no peace among the peoples of this world without peace among the world religions.

HANS KUNG

The Beloved whom everyone is seeking is the same who has covered Himself in your cloak. Why should we go to the jungle suffering from the grief of separation, for the Beloved is in our own lap.

SHARAF AD-DIN BU ALI QALANDER

The first thing in life is self-reliance. Second is self-confidence, third is self-sacrifice, and fourth is self-realisation. With self-realisation life finds its final fulfilment.

SATHYA SAI BABA

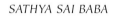

The present exists to repair the past and prepare the future.

G I GURDJIEFF

Time is but the stream I go fishing in. I drink at it, but while I drink, I see the sandy bottom, and detect how shallow it is. Its thin current slides away but eternity remains.

THOREAU

The seductive whisperings of desire are the howls of a wolf that can tear a man to pieces.

RUMI

The diversity which people experience in this creation is but an appearance, like the colours of a rainbow.

YOGA VASISHTA

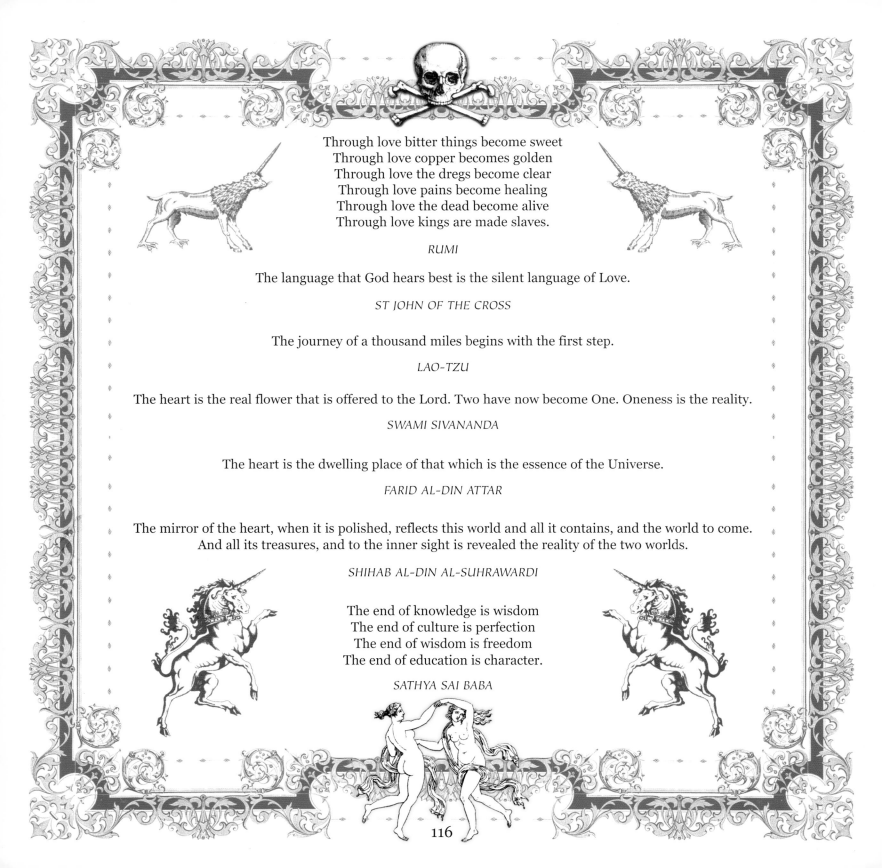

Through love bitter things become sweet
Through love copper becomes golden
Through love the dregs become clear
Through love pains become healing
Through love the dead become alive
Through love kings are made slaves.

RUMI

The language that God hears best is the silent language of Love.

ST JOHN OF THE CROSS

The journey of a thousand miles begins with the first step.

LAO-TZU

The heart is the real flower that is offered to the Lord. Two have now become One. Oneness is the reality.

SWAMI SIVANANDA

The heart is the dwelling place of that which is the essence of the Universe.

FARID AL-DIN ATTAR

The mirror of the heart, when it is polished, reflects this world and all it contains, and the world to come.
And all its treasures, and to the inner sight is revealed the reality of the two worlds.

SHIHAB AL-DIN AL-SUHRAWARDI

The end of knowledge is wisdom
The end of culture is perfection
The end of wisdom is freedom
The end of education is character.

SATHYA SAI BABA

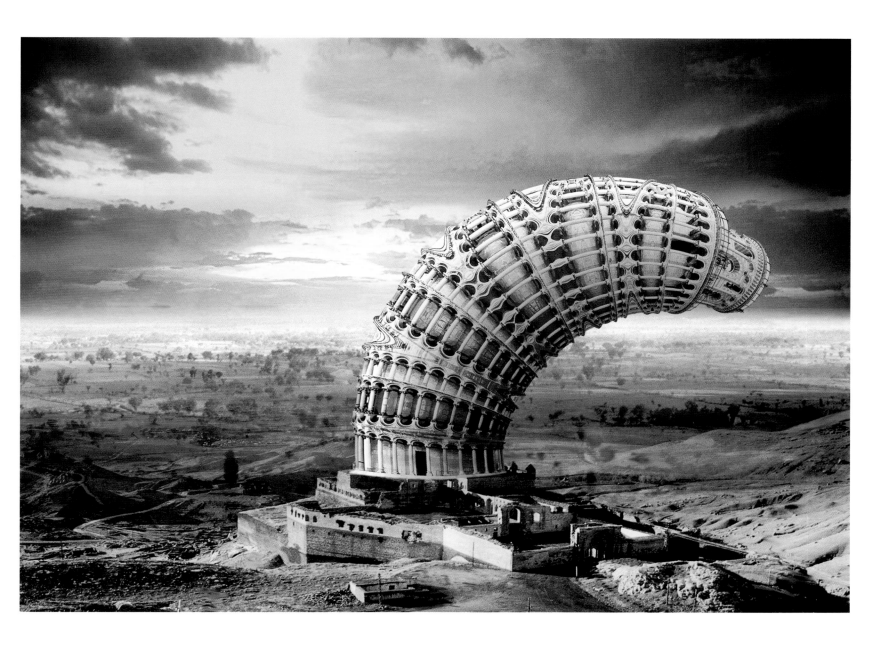

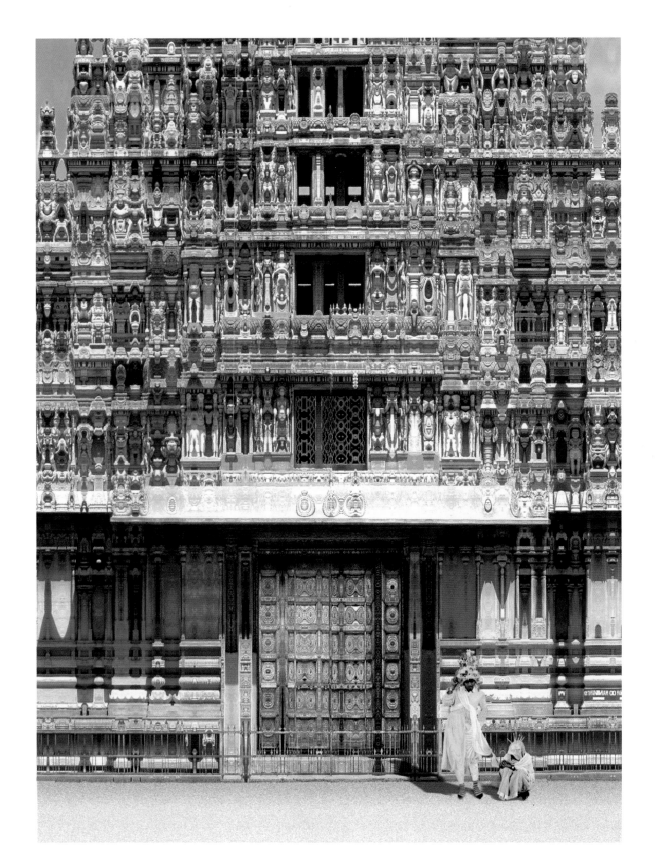

The mystic ecstasy is a flame kindled in the heart by longing for the Beloved.

AHMAD ABUL-HUSAYN AL-NURI

Thought is the basis of existence and the essence which is in it, and it is a perfect manifestation of God, for thought is the life of the spirit of the Universe. It is the foundation of that life and its basis is man.

ABD AL-KARIM JILI

The eternal wisdom made all things in Love: on Love they all depend, to Love all turn. The Earth, the Heavens, the Sun, the Moon, the Stars the centre of their orbit find in Love. By Love all are bewildered, stupefied, intoxicated by the wine of Love.

FARID AL-DIN ATTAR

The best diet in the world is the remembrance of God.

HADRAT ABU BAKR WASTI

This world is the abode of attachment, the next world is a gift of God, but this heart is the abode of God, the home of enlightenment.

HADRAT ABU BAKR SHIBLI

The builder of houses and temples and taverns is One. The buildings are many, but the Master of each is One.

CHANDARBHAN BRAHMAN

That you cannot end, that is your greatness and that you never begin, that is your fate. Your song is revolving like the starry sky, beginning is the same as the end, and what is in the centre, clearly shows that what will remain in the end, is what was there at the beginning.

GOETHE

The time has come to turn your heart into a temple of fire. Your essence is gold hidden in the dust. To reveal its splendour, you need to burn in the fire of Love.

RUMI

There is only one religion, the religion of Love. There is only one language, the language of the heart. There is only one Caste, the caste of Humanity. There is only one God and He is omnipresent.

SATHYA SAI BABA

Veil upon veil You hide the wellspring of the Infinite, the blue that delights, pierces the heart, and produces a sapphire jewel.

HERMES

When at last my eyes, worshippers of appearance, were opened, I found it already lodged in the mansion of my heart.

MUHAMMAD IQBAL

Whoever travels without a guide, needs two hundred years for a two day journey.

RUMI

When it is possible to hear the Beloved speak Himself, why listen to second hand reports.

JAMI

Whenever one acts in a way that falls below the standard set in one's heart, it will collapse.

MENCIUS

When one reaches the state of realisation of True Reality in one's own body, the mountains, rivers, the great earth, all phenomena, grass, trees, lands, the sentient and the non-sentient, all appear at the same time as the complete body of the unchanging True Reality. This is the time of awakening to one's own nature.

HAKUIN EKAKU

Who made you glorious as the gates of Heaven beneath the keen full moon? Who bade the sun clothe you with rainbows? Who, with living flowers of loveliest blue, spread garlands at your Feet?

S T COLERIDGE

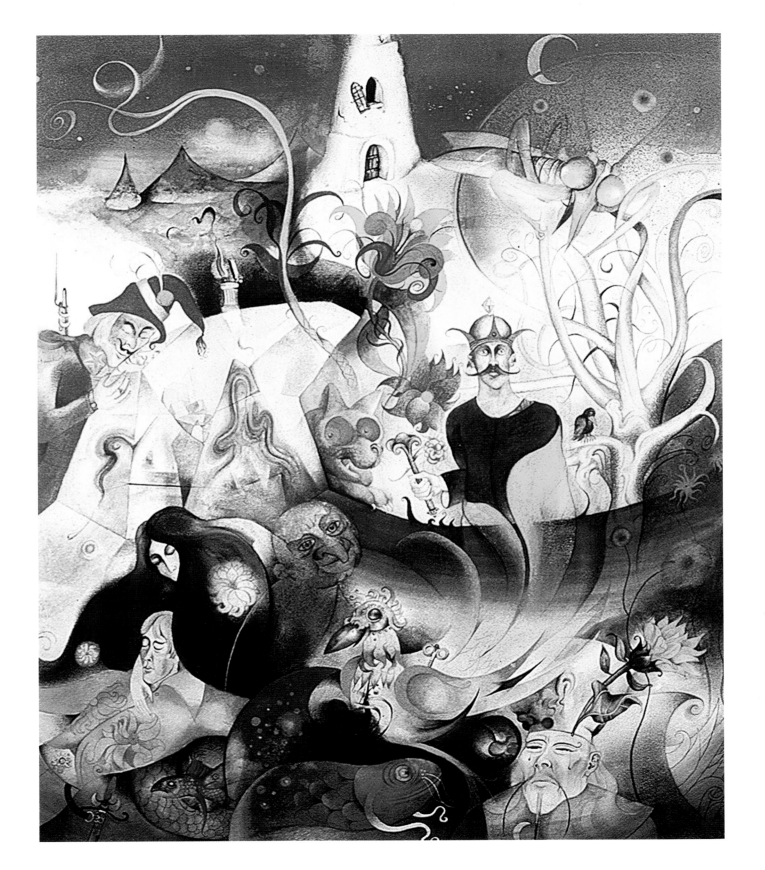

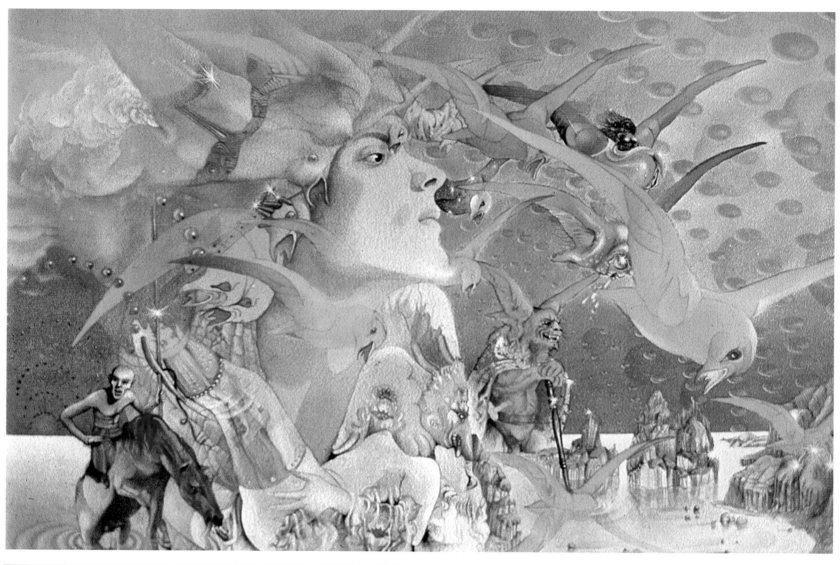

When I consider the matter carefully, I do not find a single characteristic by means of which I can certainly determine whether I am awake or whether I am dreaming. The visions of a dream and the experiences of my waking state are so much alike that I am completely puzzled, and I do not really know that I am dreaming at this moment.

DESCARTES

What we mistake for a padlock to keep us out, we may tomorrow find to be the key that lets us in.

NIZAMI

When I kept knocking on God's door, I waited mindfully, not distracted, until there appeared to the eye, the glory of His face and a call to me, nothing else. I am Encompassed Being in Knowledge. Nothing is in my heart but God.

IBN ARABI

What God said to the rose that made its beauty bloom, He has said to my heart and made it one hundred times more beautiful.

RUMI

Wealth and youth desert you when you leave this world. You leave all things behind; friends, brothers, relatives. Nobody can help when the Angel of Death comes. Then just who is your son and where is your house? Only Love holds your hand.

TRADITION BAUL

Without going out of the door, one can know everything under Heaven. Even without peeping out of the windows, one can see the working of Heaven. The further one goes out, the less one knows.

LAO-TZU

Wisdom tells me I am nothing. Love tells me I am everything and between the two, my life flows.

NISARGADATTA MAHARAJ

When you shoot the arrow, it is not you, but God, who shoots it.

QUR'AN

Where can I go from Your spirit? Where can I flee from Your presence? If I go up to the heavens, You are there. If I make my bed in the land of the dead, You are there.

PSALM 139

Who seeketh me, findeth me
Who findeth me, knoweth me
Who knoweth me, loveth me
Who loveth me, I love
Whom I love, I slay
Whom I slay, I must requite
Whom I must requite, Myself am the requital.

IRANIAN SUFI TRADITION

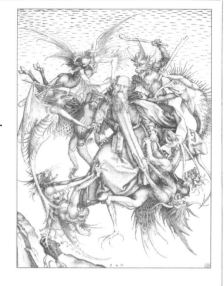

Were it suitable to speak them
Many things had I to tell you
God has said it better than I
The reins of faith are held by you.

AFLAKI

Whoever controls the mind, he is a pilgrim.

GURU ARJAN DEV

With each new breath the sound of love surrounds us all from right and left.

RUMI

When the ancient Masters said "If you want to be given everything, then give up everything" they weren't using empty phrases.

LAO-TZU

What we see by the opening of vision is an infinity above us, an eternal Presence, or an infinite existence, an infinity of consciousness, an infinity of bliss; a boundless Self, a boundless Light, a boundless Power, a boundless Ecstasy.

AUROBINDO

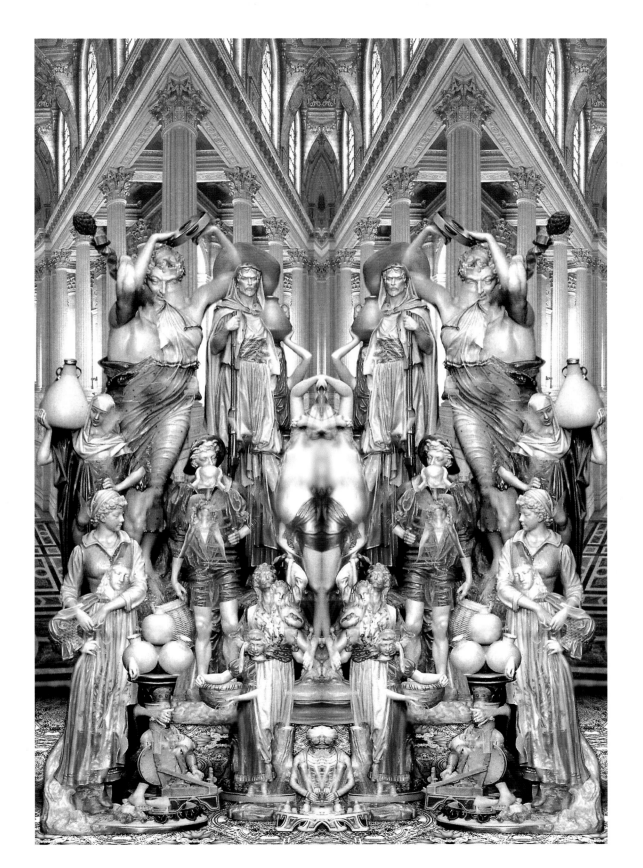

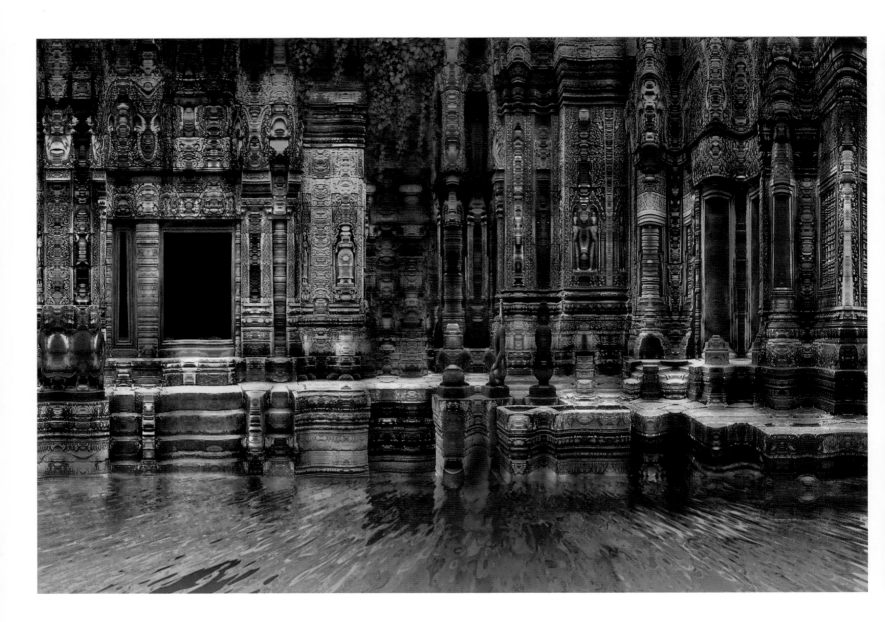

When I appealed for wealth, I found it in knowledge
When I appealed for pride, I found it in poverty
When I appealed for success, I found it in asceticism
When I appealed for disinvolvement, I found it in silence
When I appealed for relief, I found only despair.

JUNAYD

Work for this life as though you are going to live forever.
Work for the next life as though you will die tomorrow.

ALI IBN ABU TALIB

The man who rests on the mind, falls worse than an animal.
The man who rests on the intellect, is transformed into God.

SATHYA SAI BABA

With the lamp of love, night's darkness is never pitch black.

DR JAVAD NURBAKHSH

When love beckons to you, follow Him, though His ways are hard and steep.

KAHLIL GIBRAN

Work is not what people think it is. It is not just something which, when it is operating, you can see from outside.

RUMI

When we are dead, seek not our tomb in the earth, but find it in the hearts of men.

EPITAPH OF JALALUDDIN RUMI

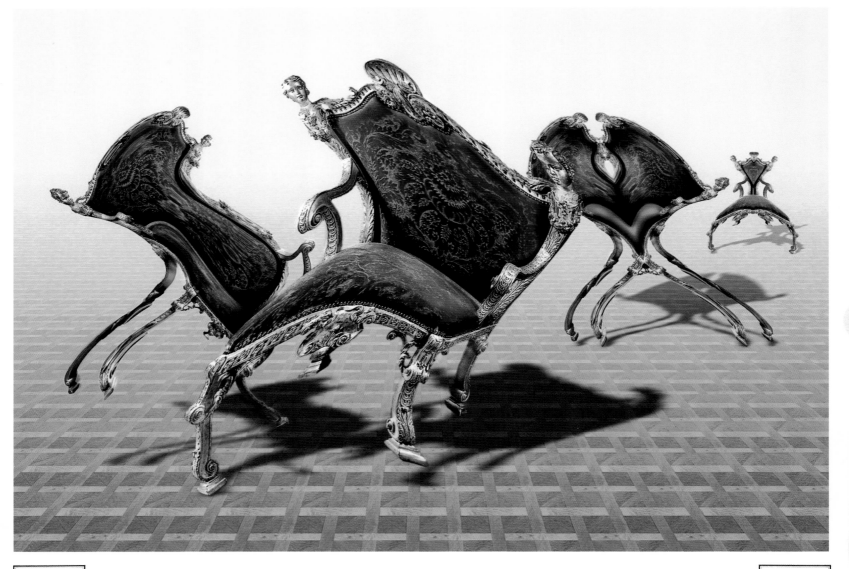

When a man of low grade hears about the Way, he bursts into laughter. If it is not laughed at, it would not be worthy to be the Way.

LAO-TZU

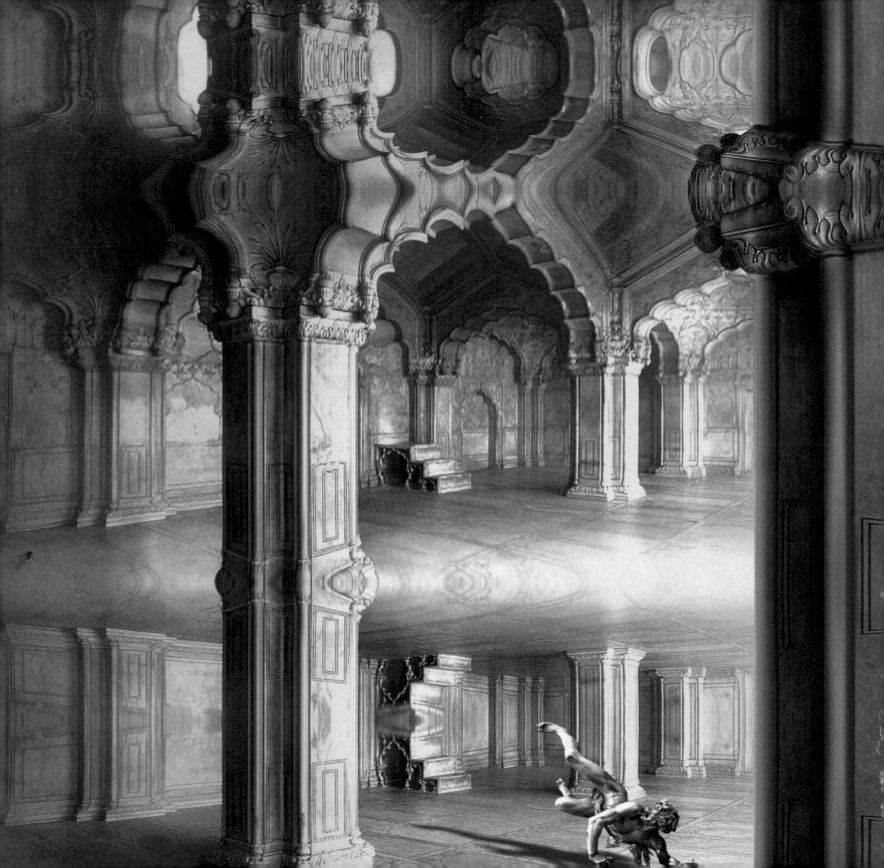